EAST LOTHIAN

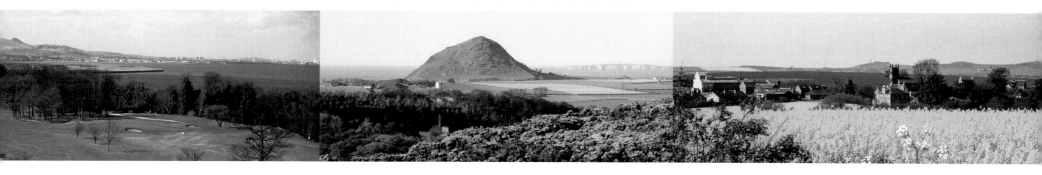

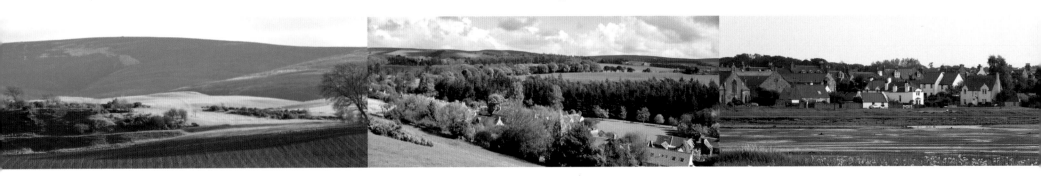

EAST LOTHIAN

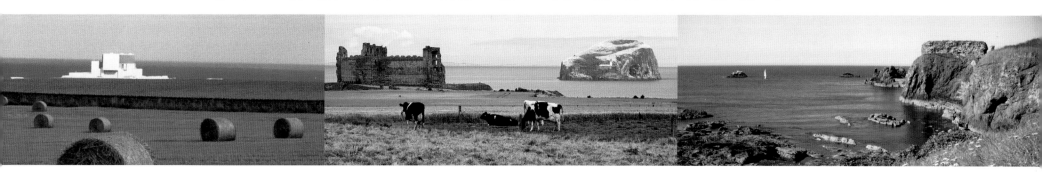

IMAGES BY LIZ HANSON

AND A SHORT HISTORY BY ALISTAIR MOFFAT

DEERPARK PRESS

SELKIRK

First published in Great Britain in 2006 by
Deerpark Press
The Henhouse
Selkirk TD7 5EY

Photographs © Liz Hanson
Text © Alistair Moffat

ISBN 10: 0-9541979-4-1
ISBN 13: 978-0-9541979-4-0

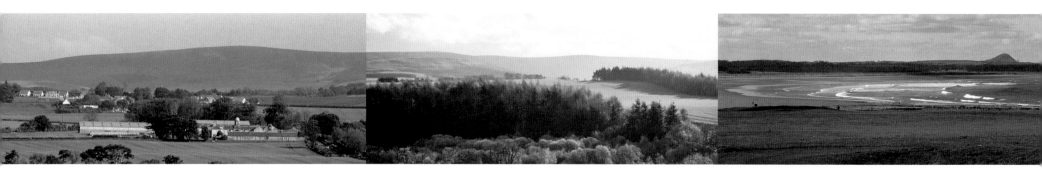

A CIP catalogue record for this book is available from the British Library.

Design by Mark Blackadder
Edited by Kate Blackadder

Printed and bound in China through Worldprint Limited

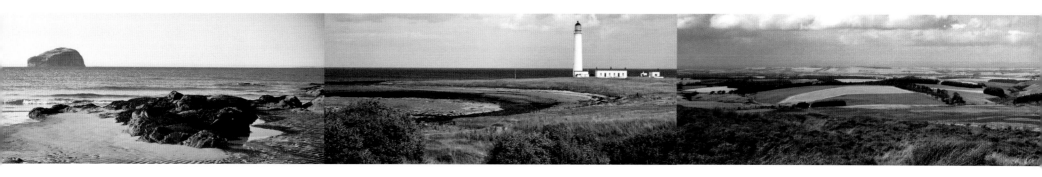

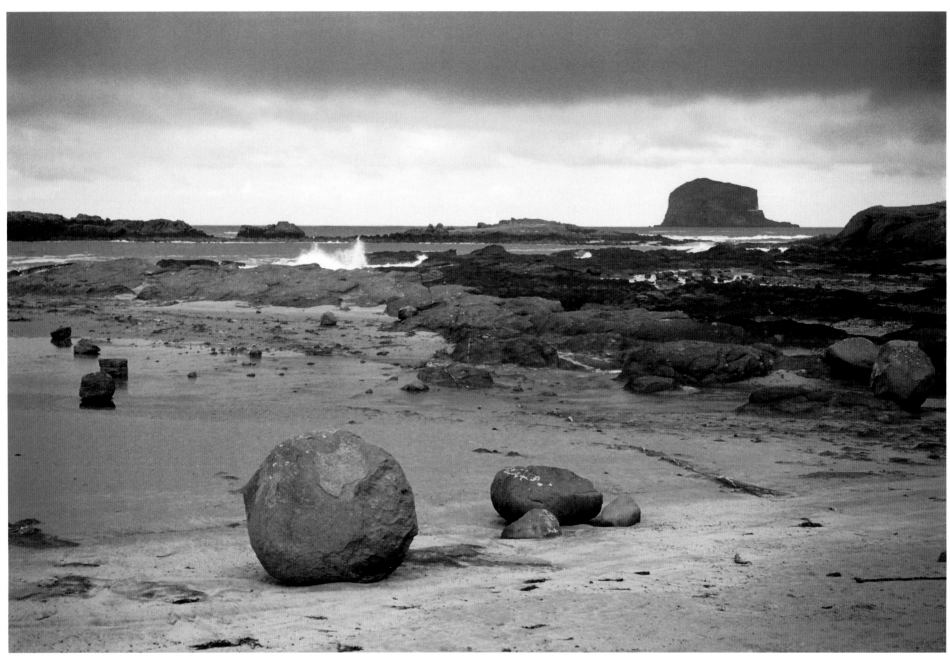

East Lothian is the deposit of an ancient collision. An unimaginably long time ago, around 420 million years BC, the crust of the Earth was moving, forming and reforming enormous continents, filling and draining vast oceans. What became southern Scotland lay on the edge of a huge landmass, and separated by a prehistoric sea, northern England lay on the rim of another. When these two continents collided, Scotland's harder rocks ground and scraped over England's leading edges, the crust of the Earth corrugated and buckled, the floor of the ancient sea was squeezed upwards, and the foundations of the landscape of East Lothian were laid down.

But in the deep past it all looked very different. The sole recognisable legacy of the welding of Scotland to England is the grain of the land. Because of the angle at which the two great continents met, the hill ranges and valleys of Scotland and much of northern England run in approximately the same direction, from south-west to north-east. The Cheviots, the Southern Uplands, the Central Belt, the Highland Line and the Great Glen all parallel each other.

Before the modern shape of East Lothian could emerge and look anything remotely like itself, more geological drama waited. Around 350 million years BC,, the tranquil northern plain erupted with sudden episodes of astonishing violence. From the mouths of volcanoes enormous tonnages of ash and dust rocketed into the atmosphere, red and white hot rivers of lava flowed from the molten centre of the Earth. The Bass Rock and North Berwick Law were once mighty cones of blackened cinders and ash. Magma spewed down their flanks and laid waste any living plant or animal for many miles around. After millions of years of erosion all that remains of this elemental power are two rounded plugs of very hard rock. When the land shook and lava

boiled upwards, it was forced up huge pipes before it burst from the summits of flaring volcanoes. And when the roar and shudder of eruption subsided and the molten rock cooled in the pipes, it was left in a circular, tube-like shape. Through aeons of time, this shape has endured – although much reduced – and the familiar forms of the Bass Rock and North Berwick Law remember the old volcanoes and their pipes.

Some eruptions never reached the surface but have left their distinctive marks on the East Lothian landscape nevertheless. Traprain Law is the residue of a laccolith, a mushroom-shaped deposit of lava which buckled the Earth's crust but failed to break through it. When erosion exposed Traprain and modern quarrying burrowed into its centre, the ancient flows of magma could still be clearly seen. The massive pressure of other lava flows prised rock strata apart and then cooled into very hard wedges known as intrusions or sills. These formed several features, including the offshore islets of Fidra and Lamb.

James Hutton knew the rocks of East Lothian well. An Edinburgh man who farmed in Berwickshire, he became wealthy through his involvement in the early chemical industry, inventing a process for making ammonia. This allowed Hutton to devote all his time to a passion, his consuming interest in geology. In 1788 he and a friend set sail from Dunglass Cove, a few miles south of Dunbar. They wanted to examine the nearby sea-cliffs and their exposed rock strata. When Hutton saw the formations at Siccar Point, he realised that traditional creationist views of the origins of the Earth could no longer stand. Some of the strata were near-vertical, showing the convulsions caused by the ancient collision between Scotland and England. Others were horizontal, sedimentary rocks laid down after the continents had ground into each other – and they were clearly younger. Their position and nature demonstrated that. At Siccar Point James Hutton could see the immense age of the world written on its rocks, and his Theory of the Earth began modern geology.

Much of the erosion which exposed the buckled strata on the East Lothian and Berwickshire sea-cliffs and made the volcanic plugs poke up through the northern plain was caused by ice. For the last two million years the earth has seen long periods when large areas of its surface were locked in the frozen grip of a series of ice ages. At their height, the landscape was sterile, white and pitilessly inhospitable. As incessant hurricanes whipped around the foot of the ice-domes, vast conical mountains of ice packed hard into blocks kilometres thick, nothing could live, no plant or animal. Around 18,000 years ago, when the last ice age was at its zenith, the endless horizons of the snowfields reached down to South Wales and the English Midlands. But

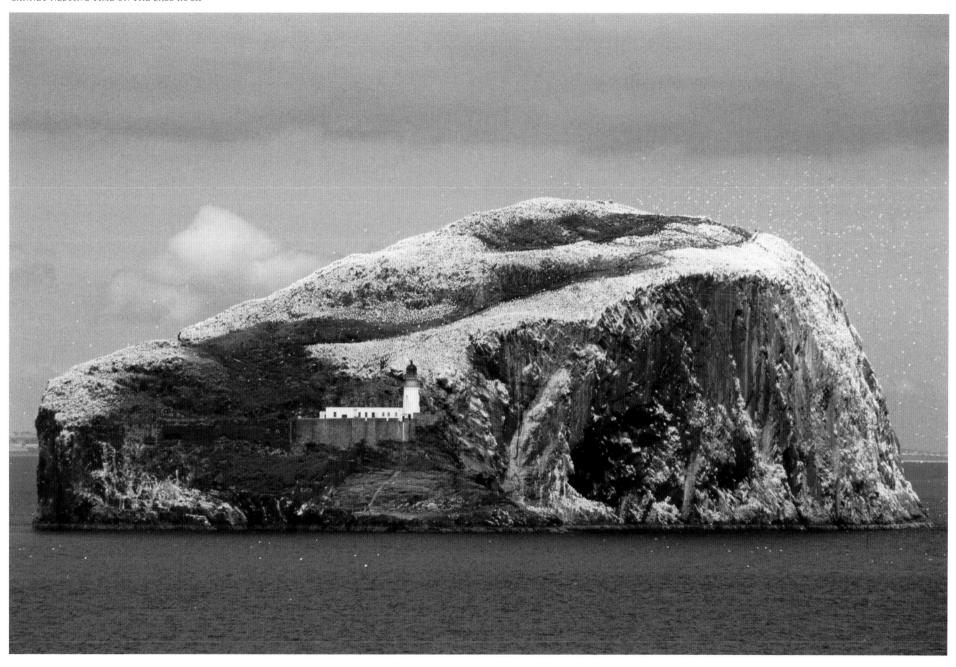

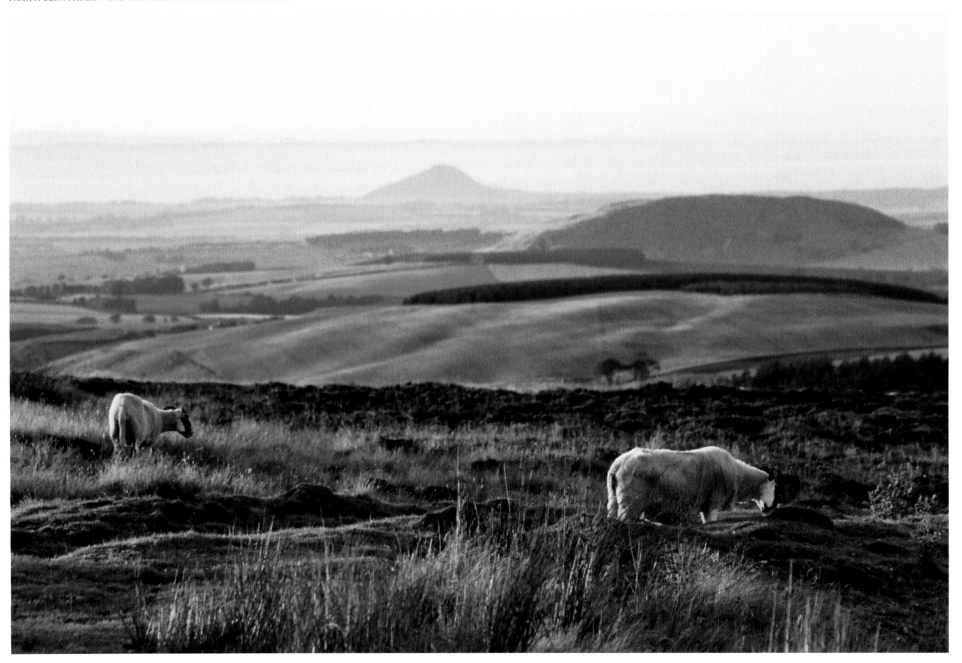

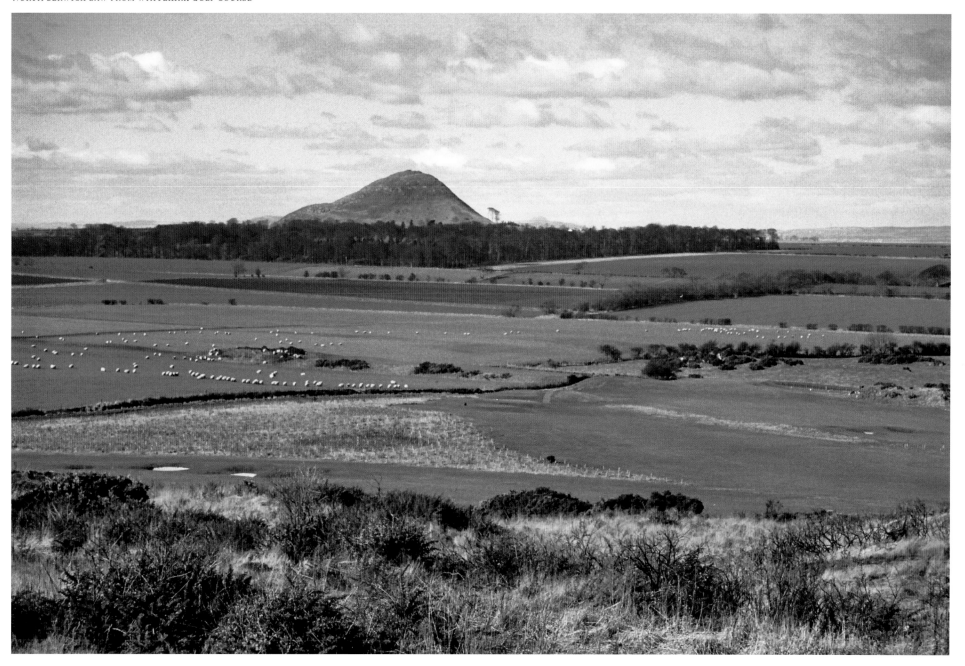

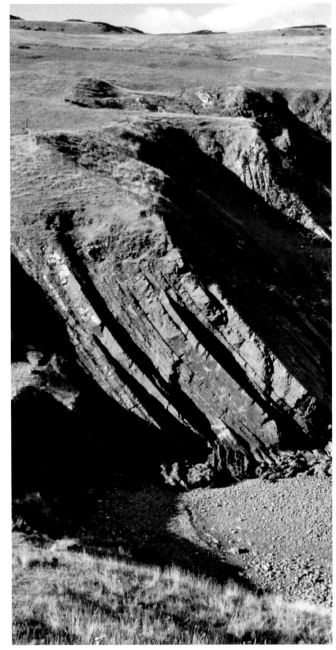

VERTICAL STRATA, PETTICO WICK, BERWICKSHIRE

STRATA, TYNE SANDS

TYNE ESTUARY

12

over a series of warmer summers, the weather began to improve and the great domes groaned and cracked. Very slowly the ice moved, and it began to create the shape of the modern landscape.

Following the west-to-east grain of East Lothian, glaciers rumbled down from the ice-dome over Ben Lomond and rocks and debris trapped inside them scarted over the Earth's thawing crust. Bulldozing boulders, gravel, sand and soil, they shaped the valleys and the plain, breaking open new water-courses, covering over old ones. As the tide of ice, detritus and meltwater flowed around its flanks, North Berwick Law stood fast, its hard volcanic rock unmoving. To the east of the Law, on the leeward side, there is a distinct tail of debris which shows clearly the direction of the glacier. Perhaps Edinburgh Castle rock and the tail on which the High Street is built is the most famous example of this effect. As other plugs were exposed the ice arranged

East Lothian's geography around them, creating a clearly visible set of nodal points. On the southern margins, the Lammermuirs emerged, rising out of the edges of the ice-sheet at their foot. Torrents of meltwater cut deep channels as the weather warmed and the ice shrank northwards. Often no modern water-course found its way into the meltwater channels and around Garvald several of these dry deans can be seen, the valleys of lost rivers made and then unmade by the retreat of the ice.

Geology shaped the land of East Lothian, and the land has shaped the lives of its people – even now. The rocks laid down in the west of the area had coal seams ribboned through them, some near the surface and easily dug. In the centre the fertile flood plains of the River Tyne and the rolling upland pasture of the south and east encouraged farming. And these geological contrasts have made East Lothian a marginal parliamentary constituency for most of the last 60 years. The

miners in the west traditionally supported Labour candidates, while the farmers in the centre and the east voted Conservative. Talented losing MPs like John P. Mackintosh and Michael Ancram had only the rocks to blame for their being turned out of office.

The levels of the North Sea fluctuated in prehistory and much of the East Lothian coastline has a legacy from that time. Raised beaches, many fringed with wind-blown sand dunes, are strung from Musselburgh to Dunbar. Most of this was marginal land, good only for pasture and eventually it was colonised for a popular pastime. Golf was a product of East Lothian's geology and even the form of the game itself has been shaped by the land. The narrow shelf-like nature of these sandy areas forced courses to be laid out with nine holes out and nine holes back. Bunkers were natural, sometimes sheep-scrapes, bields against the wind. Their inclusion in inland courses seems odd now,

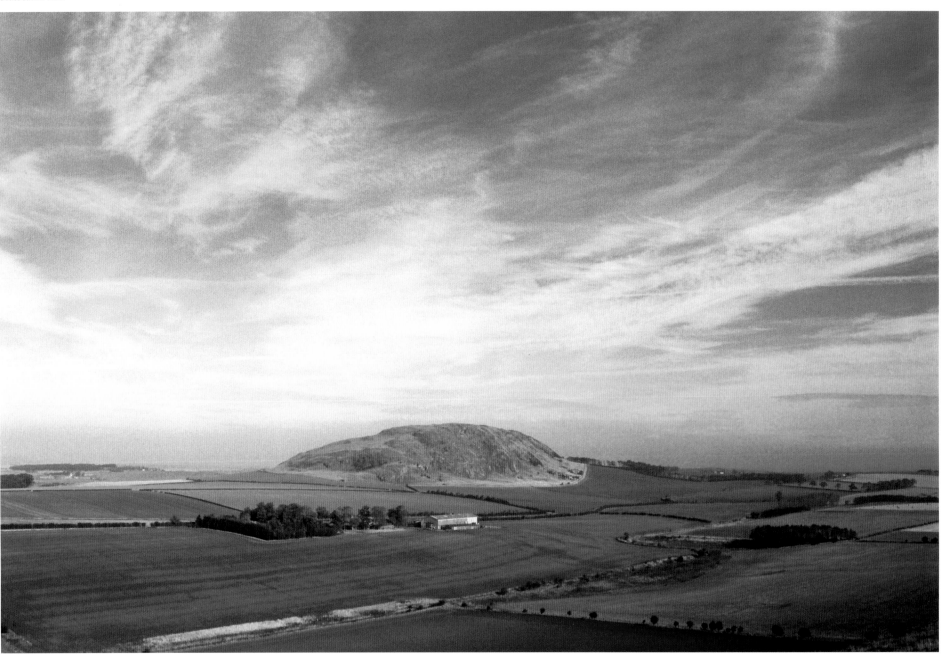

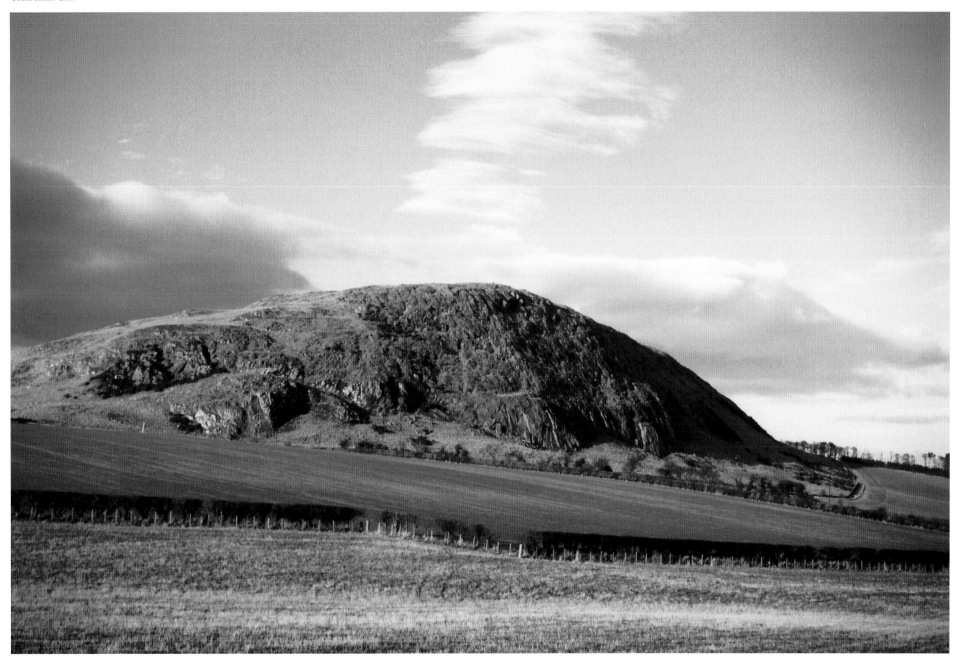

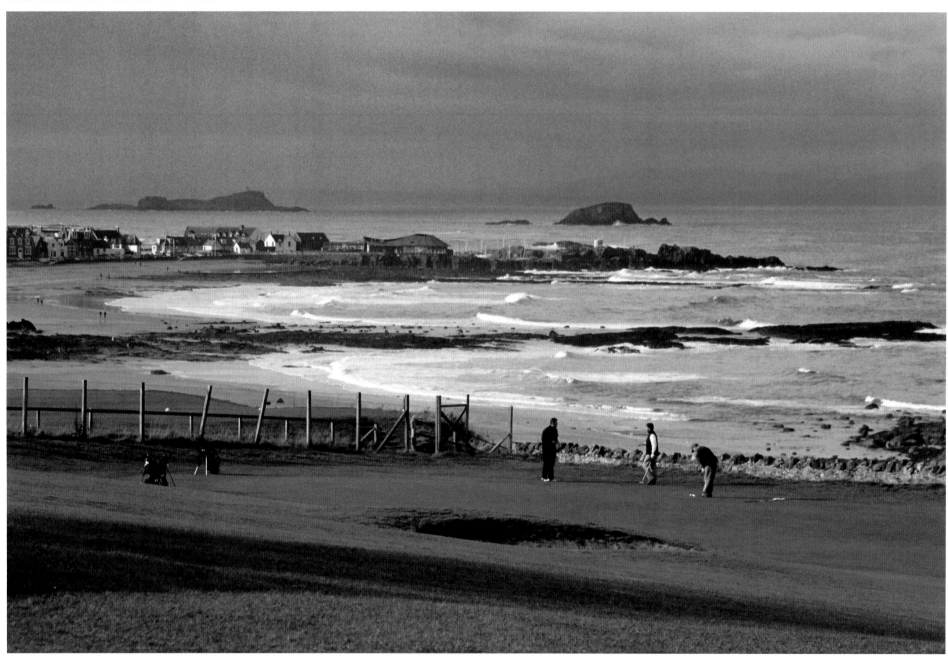

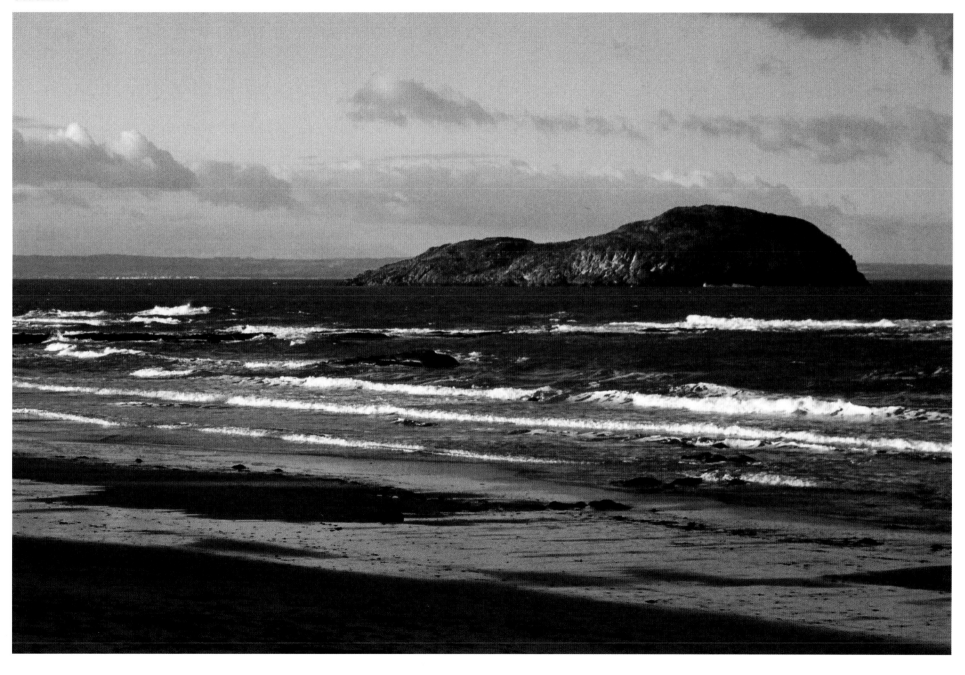

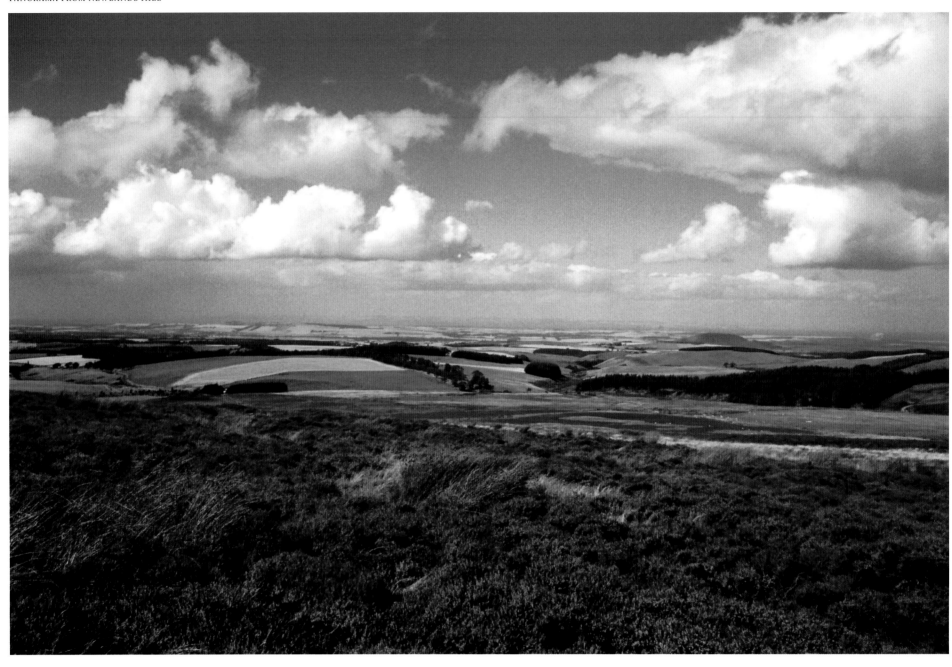

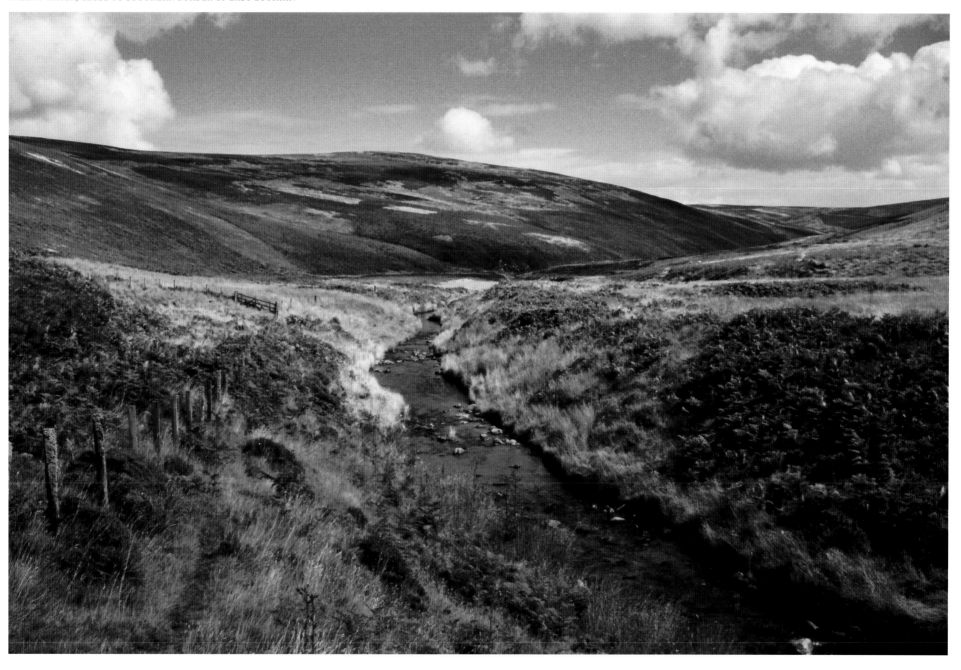

a matter of tradition rather than anything else. Tees were set on top of dunes. Greens were grassy hollows, and places where beasts had regularly cropped the grass were fairways. And the rough could be very rough.

But all of this lay far in the future. Around 12,000 BC the snowfields of the last ice age were giving way to tundra. Each summer the permafrost melted for a few months and plants began to grow again, grasses, sedges and herbage. Herds of grazing animals followed; reindeer, caribou, red and roe deer and wild horses. These were all flight animals and on the wide summer grasslands they could see for long distances, far enough to make out predators on the horizon. The most deadly were human beings, bands of hunters who followed the migrations of the herds, hoping to pick off stragglers at river-crossings or narrow defiles. These bands of pioneers came up from the warming south, doubtless skilled archers, trappers, and good with a throwing spear. At first they came only for the summer hunting season, but as the weather slowly improved some may have decided to stay on through the winter.

The coastline of East Lothian almost certainly sheltered the first pioneers, but it is highly unlikely that any trace of them will ever be found. Around 12,000 BC the level of the North Sea was much lower and the Firth of Forth scarcely existed, being no more than a shallow bay whose mouth lay well to the east of May Island. Any flint tools or other evidence left by the early hunting bands will likely lie untouched on the bed of the modern sea.

There is another, very compelling reason why any traces will be faint. Around 9,400 BC the weather suddenly worsened and the Arctic cold crept back over the land. Thousands of miles to the west an ecological disaster had burst over the world. As the ice-sheet shrank over North America, a huge lake of meltwater spread over central Canada, very much larger than the Great Lakes. Archaeologists have called it Lake Agassiz. To begin with it drained slowly to the south down the course of the Mississippi and into the Gulf of Mexico. But as the ice-dams to the east melted, the immense lake trickled into the St Lawrence Basin. And then, over only two or three days, the trickle became a torrent and Lake Agassiz burst through the dams and roared into the Atlantic. Levels rose by 30 metres, inundating numberless communities of hunter-gatherers all round its shores. But even more dramatically, the fresh waters of the huge lake so diluted the ocean that the Gulf Stream stopped flowing north-eastwards and was turned away to the south. Very quickly the weather changed, storms blew once more, an ice-dome formed over Ben Lomond and the pioneers fled south.

For a thousand years the north was empty again, bleak, and although the glaciation was much less, little

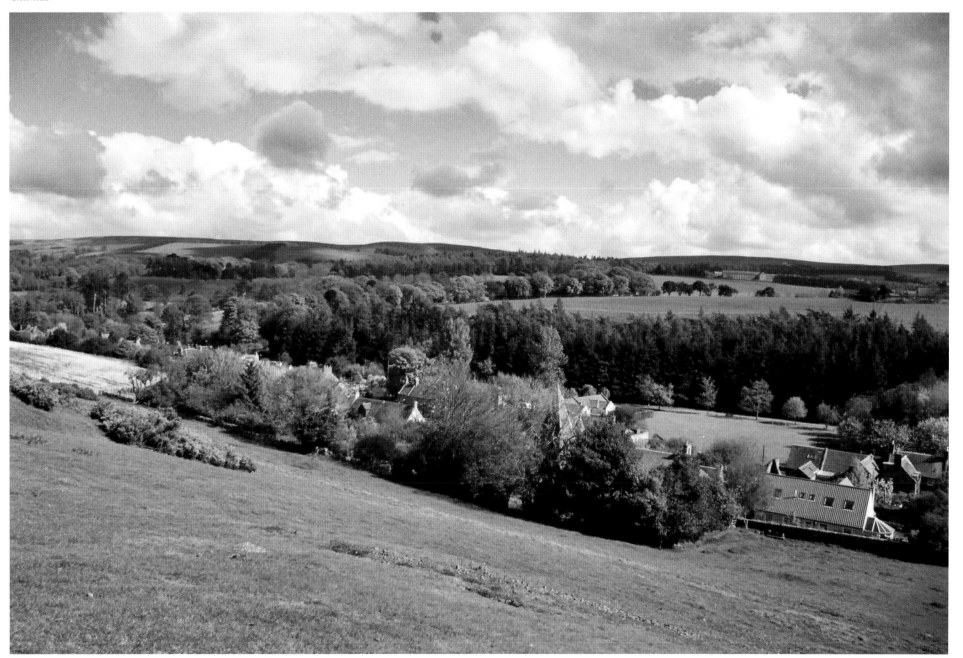

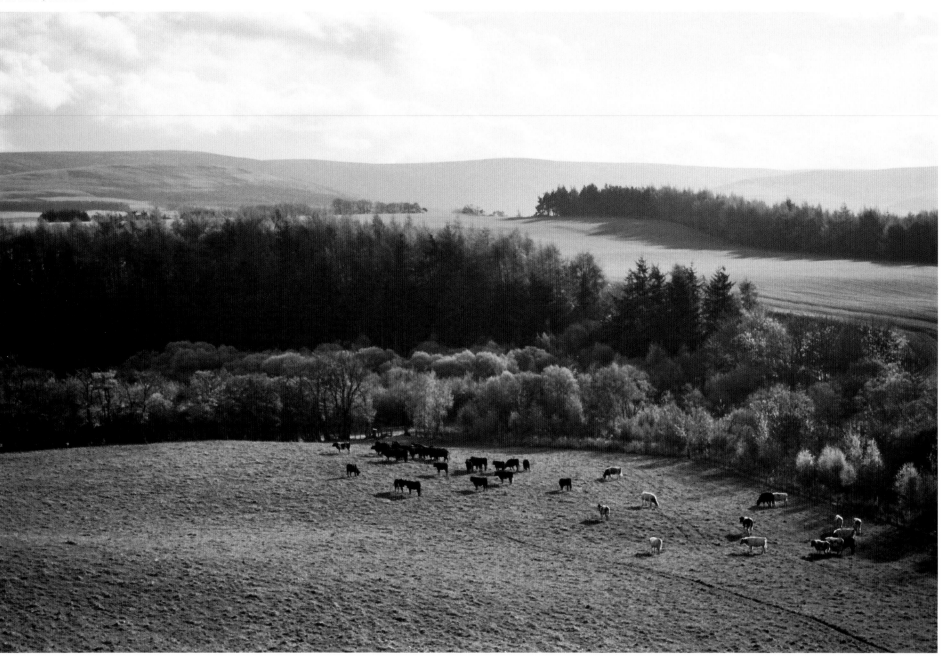

vegetation grew and no animals thrived. Then quite suddenly, the Atlantic recovered sufficient salinity for the Gulf Stream to flow north again. The weather warmed, herds ventured north and pioneer bands followed them. And the continuous human history of East Lothian at last began.

• • •

Cement has done much for the study of prehistory on the southern shores of the Firth of Forth. When Blue Circle decided to extend limestone quarrying at their cement factory near Dunbar, archaeologists were permitted to survey and dig test pits in the area to be affected, near East Barns Farm. And they found something spectacular.

In the autumn of 2002, in a shallow hollow in an otherwise unremarkable field, John Gooder and his team came across the remains of a prehistoric house. Scraping carefully at the soil, they exposed the rim of a sunken floor. It was oval in shape and measured 5m by 5.8m. Around its edges discoloured pockets of soil were recognised as post holes. Diameters varied between 25cm and 55cm and most of the holes had been cut at an angle, strongly suggesting that the timber posts they had contained sloped inwards, forming a roughly conical roof.

So far, so intriguing. Inside the area encircled by post holes, the excavators came across organic remains. These were critical finds, especially some fragments of charred hazelnuts. Organic matter can be carbon-dated and since hazelnuts grow only in one year, dates derived from them can often be very accurate. The results were sensational. The data told the excavators that the timber house at East Barns had been built and occupied around 8,000 BC, making it – by some distance – the oldest house yet found in Scotland. At Cramond, near Edinburgh, traces of a shelter, with stake holes rather than post holes, had been found and dated to around 8,500 BC, and at Daer, near Biggar, and Manor Bridge, near Peebles, similar signs of occupation from the same period had come to light. But none of these could be described as houses, none could compare with the solid – even massive – structure which had been raised at East Barns.

Post holes of 55cms had been dug to hold substantial timbers, probably the trimmed trunks of mature trees and they will have achieved a roof height visible from some way away. Excavators also found evidence for walling, probably turf, and their report speculates that the thick house timbers could have supported a heavy roof, perhaps also made from turf.

But it is the sheer scale and architectural complexity of the East Barns house which is so

stunning. Historians have traditionally seen the pioneers who came north after the retreat of the ice as hunter-gatherers, family bands who moved quietly through the landscape in pursuit of game and in search of the seasonal wild harvest of fruit, roots, nuts and berries. Living in shelters made from stakes shoved in the ground or in caves or rocky overhangs, they left little trace of their passing, barely rustling the autumn leaves as they flitted through the Wildwood.

Life at East Barns in 8,000 BC was not like that. To justify investing all that time, effort and skill in building the big roundhouse, the pioneers must have insisted on some claim to own the land around it, or at least to enjoy a set of customary rights to what it produced. And it has been conjectured that the very act of building the house, a substantial, permanent dwelling, staked these territorial claims to any who might come to challenge them. Around Scotland's prehistoric coast huge shell middens were piled up by hunter-gatherer communities and archaeologists believe that their sheer size established long-standing claims of right and ownership.

Why East Barns? To a prehistoric eye, it was a good place to live all the year round. In the summer and autumn the woodland around the house provided wild berries, fungi, nuts, roots and fruit such as crab apples. This was likely children's work although the harvesting of what looked like a mushroom would have been left to the more experienced. Further afield game could have been trapped and snared, and the steep-sided valleys of the Lammermuirs which lie immediately inland were good places to drive and kill deer and the great prehistoric wild cattle known as the aurochs. Flint-tipped arrows and spears were made at East Barns, more than 30,000 flakes and scraps were found, evidence of regular and long-term work.

Archaeologists believe that in 8,000 BC the shoreline lay only 300m north of the house, and its proximity meant that the pioneers would – literally – have enjoyed the best of both worlds. A charred piece of seal bone was found on the site. And the wide expanse of rocks exposed at low tide around Barns Ness was a good place to gather shellfish, crab and other seafoods available even in the hungry months of winter and spring. Seabirds' eggs and the young, unfledged birds themselves could have been taken from the cliff ledges along the coast. Younger prehistoric skeletons from the Orkney Islands showed that people had developed articulations for extra joints on their toes and a third joint on their thumbs. This was to enable them to hang on to the slippery rocks, fight off the shrieking parent birds and take their eggs or young birds from their nests. And near the house at East Barns, the pattern of convenience was completed by the Brock Burn, a reliable source of fresh water.

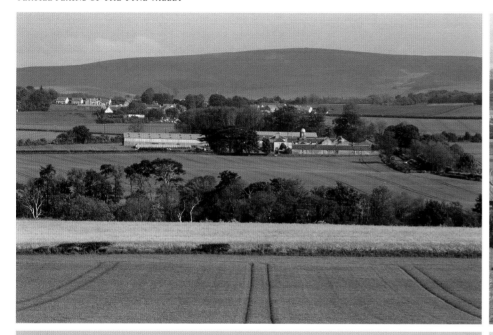

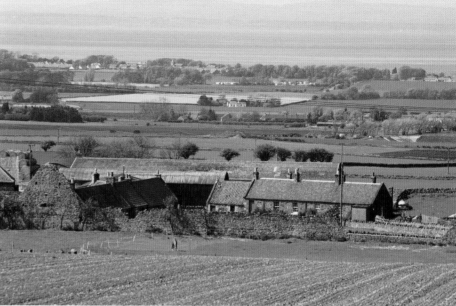

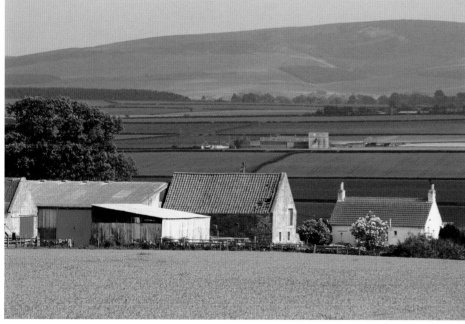

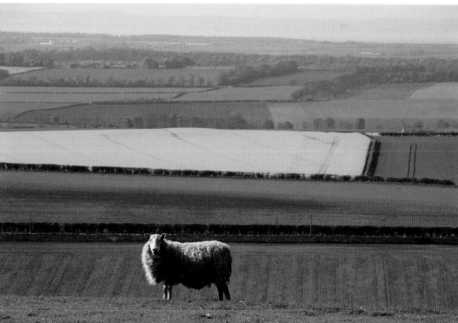

26

SETON SANDS

MARITIME PLANTS IN DUNES, NORTH BERWICK

No doubt there were handy trickles even closer.

Who were these people? The excavations at Cramond and elsewhere suggest pioneers arriving in the north just as the ice-sheets were shrinking again. Perhaps they first came in summer hunting parties, tracking game as it migrated north in search of fresh pastures. Perhaps they camped close to the edges of the ice-sheets, and then made their way back to southern bases in the late autumn when the weather closed in.

The East Barns people may also have begun to come north only for the summer, and as the weather improved rapidly with the resumption of the Gulf Stream, they decided to settle. It may be that their kindred had heard stories about the lands to the north, stories brought back by refugees from the time when ice-domes re-formed over Ben Lomond. When they set out for East Barns, perhaps they knew where they were going. It is possible.

No human remains were found in or near the big timber house, but some sensible conjecture is possible about the appearance of the people who made it. The pioneers were emphatically not the grunting stereotype of the caveman, constantly raising his bushy eyebrows in bemused surprise at almost everything. Low foreheads, ragged animal skins and clubs are the stuff of 19th and 20th century invention and they say more about us than the prehistoric peoples they misrepresent. Analogy with other hunter-gatherer societies is more helpful and it suggests a fit, agile, observant, adaptable, inventive and short-lived people. Perhaps at East Barns they wore buckskin, close-fitted and decorated like the tunics of the North American Forest Indians.

Their roundhouse was built to accommodate six to eight people, and it looks as though this was a family band. But it cannot have been an isolated group. Grown children needed marriage partners, people are naturally avid for news and perhaps they had items to trade or give as formal gifts. If the early settlement at Cramond developed into something more permanent (but now lost under the modern village) then the East Barns people would almost certainly have known their distant neighbours. Across the Firth of Forth, at Fife Ness, archaeologists have found traces of what might have been a fishing camp, dated around 7,500 BC. If these three communities overlapped, it is likely that they went visiting by boat. Because every component is organic and insubstantial, there are no excavated remains of the sort of boat they might have used. Only an ancient and surviving tradition suggests that the East Barns, Cramond and Fife Ness people sailed in skin boats, what the Irish still call curraghs and coracles. All the materials were to hand; a hazel-wood frame lashed together with gut, covered with a treated deerskin hull and caulked with fat or resin. Much later a legend of the

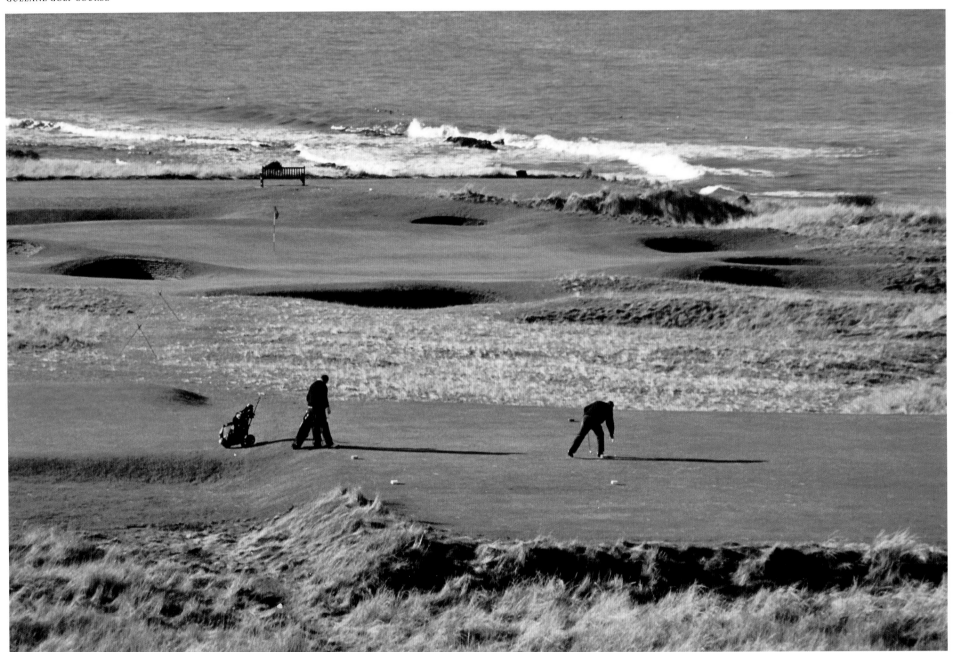

Dark Ages talks of coracle building in East Lothian. And a prehistoric logboat, or dugout canoe, has been found at Friarton near Perth; it may be that at least two styles of craft sailed the inshore waters of the North Sea.

For it is certain that the pioneers and their descendants prefered to travel on water. Along with the rest of Britain, East Lothian was carpeted with a dense wildwood after the end of the last ice age. Trees grew almost everywhere, and up and over the Lammermuirs a green canopy stretched as far as the eye could see. In summer it was dense and humid on the floor of the wildwood, in winter dark and perhaps frightening. And it was very easy to get lost. The landmarks of North Berwick Law, Traprain Law and the Bass Rock helped but it was necessary to climb a tree to find them – if they were not obscured by a ridge or the shoulder of a hill. Most paths were made by animals and the only reliable navigational aid was water. Streams ran into rivers and rivers eventually ran into the sea. And it was also much faster and safer to travel in a boat. If the rocky river bottom forced a portage, it was easy to lift a curragh or coracle and carry it to where the water ran deeper. Sea travel was a simple matter on a calm day if the action of the tides was understood and a horizon of seamarks familiar.

Many of the sea and landmarks seen by the early peoples of East Lothian have remained unchanged, the white mass of the Bass Rock, the cone of North Berwick Law, the hump of Traprain. But there is one spectacular difference. When a band of hunter-gatherers from East Barns paddled out beyond Barns Ness, they made way out into a North Sea unrecognisable to us now.

Europe's most massive ice-dome lay over southern Sweden. At least half a kilometre thick, its crushing weight pressed hard on the crust of the Earth, pushing it down more than 800m lower than it is now. This caused a fascinating reaction, one which is still being felt today. Far to the south, the ice-free land rose up in what geologists call a forebulge, and this had the effect of lifting the land much higher. The whole of the southern basin (and initially much of the north) of what is now the North Sea became dry land, some of it forming into a range of hills. These are now the shallows known as the Dogger Bank. Lying in the middle of the sea, the bank is not a sandy shoal shifting with the winter storm-tides but a range of submerged hills with valleys, plateaux and a long plain to the south of them. After the Dogger Bank archaeologists have named this drowned subcontinent Doggerland. It is a real Atlantis, not the stuff of misty legend or mythic imaginings but a lost prehistoric certainty.

Archaeological finds from Doggerland began to come up from the bed of the North Sea in 1931. Night-

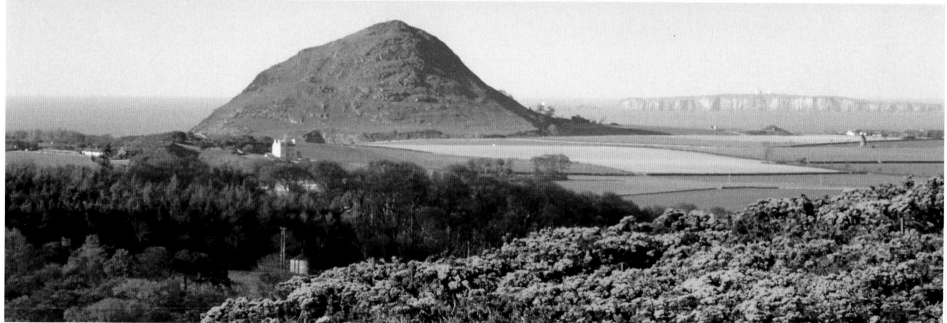

FIRTH OF FORTH TO THE EAST WITH THE ISLE OF MAY

34

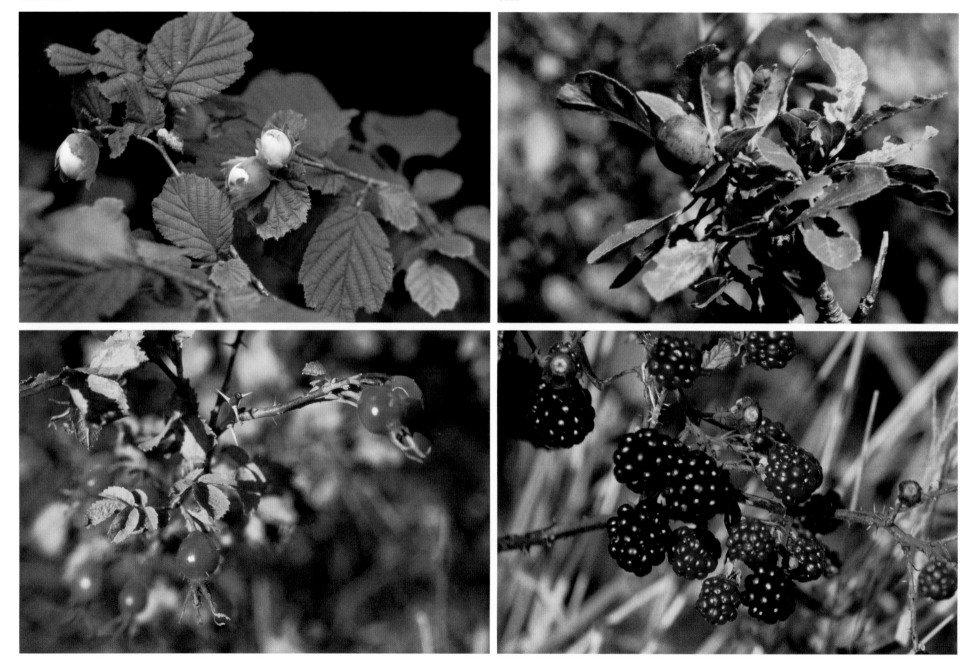

ROSEHIPS

BLACKBERRIES

fishing off the East Anglian coast, Captain Lockwood of the SS *Colinda* found a bone harpoon embedded in a clod of peat hauled up in his nets. Flint and other stone tools have been recovered by divers since then and conjectural reconstructions have been built with computer graphics.

Doggerland was a good place to live. Wide estuaries sustained year-round settlement with plentiful stocks of fish, shellfish, water-fowl and their eggs. In the Dogger Hills deer, boar, wild horses and aurochs could be tracked and brought down, and in the dense woodland a wild harvest ripened. Some archaeologists believe that the great subcontinent was the cradle of hunter-gatherer-fisher culture in north-western Europe. Far from being a mere landbridge between the European landmass and the higher and more mountainous British Isles, Doggerland was a destination in itself, a fruitful place alive with game, able to support more than a sparse prehistoric population.

In 5,840 BC the world suddenly changed. A part of the North Sea which never became dry land was the long trench known as the Norway Deeps. More than 700km long, 30km wide and 800m deep, it lies off the rocky coast of Norway, arcing parallel to it from south-east to north. The Deeps is a subduction trench, a place where undersea silt, sand and debris is absorbed into the Earth's mantle. Sliding very slowly, one tectonic plate moves under another, the harder continental shelf, and carries with it millions of tonnes of material.

But in 5,840 BC, it happened all in a moment. There occurred a massive undersea landslip. In seconds a huge volume simply disappeared into the bowels of the Earth. A vacuum was instantly created, the North Sea was sucked down, and the sea-bed exposed as it seemed that the tide raced out – by hundreds of miles. Fish flapped, boats were stranded and those who lived on the coast were open-mouthed. What was happening? Were the gods angry? Was this the end of the world?

Seagulls probably heard it first. Shrieking high into the air, they saw where the roar came from. And then the people looking out from the East Lothian coast watched the wrath of the gods thundering towards them. At around 500 km an hour, a gigantic wave, a tsunami, raced across the sea-bed. It was already too late to run. When the tsunami smashed into the shoreline, it snapped trees like matchsticks, picked up huge boulders and threw them inland, destroying and killing in its apocalyptic path.

In East Lothian the destruction will have been extraordinary, geography ensuring that it faced the full force of the wave. But in low-lying Doggerland it may have drowned much of the subcontinent permanently, carving out the Dogger Hills as an island. In the dazed aftermath, those bands of hunter-gatherers who survived

probably began to abandon their homeland and some will have sailed west to come ashore in East Lothian.

Evidence for the tsunami of 5,840 BC was discovered – as often happens – by archaeologists looking for something else. In an excavation to find the remains of medieval Inverness, they came across something unexpected, a thin layer of white, pelagic sand. This comes only from far out on the sea bed and it was possible to date its arrival onshore to 5,840 BC. The sand was the deposit of a disaster.

By 4000 BC Doggerland had drowned and its people dispersed, but communication across the North Sea and what became the English Channel appears not to have diminished. In the fourth millennium an idea sailed from the shores of Europe and made landfall in eastern Britain. It was an idea which would spark the most fundamental revolution in human history.

Farming came to Britain in boats. It came with small domesticated animals like sheep, goats, pigs and the small cattle of the time; it came in bags of dried seed grain and most important, it came as knowledge, a different way of living. After 4000 BC men and women arrived in East Lothian, almost certainly in very small numbers, who knew how to milk ewes, how to make cheese and preserve it, or who knew the best soil, the best location and the best time for planting cereal crops. This knowledge came slowly, probably in phases, almost certainly from the south as people and ideas coasted up the North Sea shore. Farming also saw hesitation. Some communities took it up and then reverted to the hunter-gatherer way of life. As many in East Lothian know, the reality is that farming is hard work, much harder than the old life of trapping and ingathering the wild harvest. The question which troubles some historians is why? Why did the prehistoric peoples adopt a method of cultivating their food which took much more time and effort than the old ways?

Perhaps the gods made it happen. Over much of Europe, the most dramatic evidence for the development of farming is the creation of religious monuments. Some, like the stone circles on Orkney and in Wessex, are famous and all of them are mysterious. Nothing is known of the ceremonies which took place inside the circles and on their approaches, and little sense of the spiritual lives of the early farmers is available past the simple observation that it was vigorous and profound – and different from what had gone before. Because farming made the monuments possible. When surpluses of food were produced and stored well, large groups could afford to devote time and considerable energy to doing something which was not obviously productive, had nothing directly to do with farming. They could spend millions of man-hours raising their elaborate monuments. Their creation also implies a hierarchy of

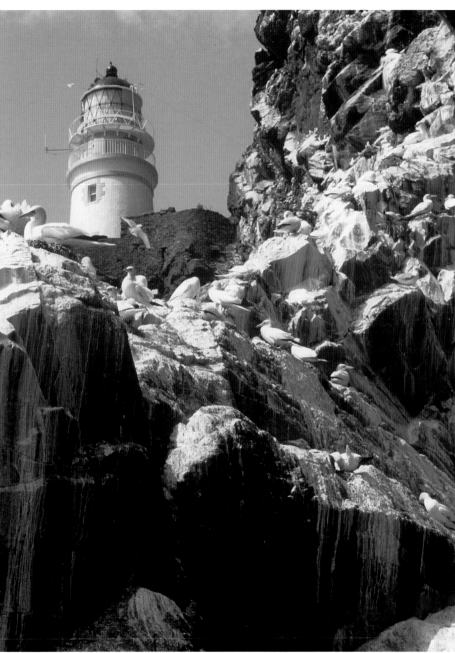

MUSSEL SHELLS

WOOD BLEWITTS

SEAWEED

SCALLOPS

some sort, or at least a directing mind or minds.

Unlike Orkney and Wessex, East Lothian is not rich in the farmers' monuments. There is nothing as spectacular as the East Barns find. Perhaps many structures were made from perishable wood. The largest henge in Scotland was discovered at Dunragit near Stranraer and nothing survives above ground because tree trunks were used instead of standing stones. Much of the landscape of East Lothian has been intensively farmed for centuries; the plough, the enclosure movement and the need for good drainage all no doubt obliterating much archaeology. One farming culture simply overlaid another.

But there are some monuments. At Drylawhill, near East Linton, aerial photography has detected the remains of a cursus. These are baffling prehistoric structures. Aerial observers could see two parallel ditches running for 300m. About 60m apart, they delineate a substantial area. What was its purpose? There are longer and more elaborate cursus monuments in Scotland; for example the Cleaven Dyke in Perthshire is two kilometres long and has a central bank flanked by two parallel ditches. No-one knows how they were used (one attractive theory holds that they were places where the ashes of the dead could be scattered) but they did exhibit power, organisation and a hard-working dedication to godliness – of some mysterious sort.

Small stone circles have survived in East Lothian, mostly up in the Lammermuirs where ground disturbance was much less. Between Gifford and Cranshaws there is a concentration. The most extensive circle has 30 stones upstanding on Kingside Hill; there is another at Crow Hill and at Nine Stone Rig there is a third, with nine stones. To the south of these, just over the boundary into the Scottish Borders, is the Lammermuirs' most impressive monument, the Mutiny Stones. A long and large cairn, it appears to have been used for burial of some kind, and it is interesting that its compass orientation follows the north-east to south-west grain of the land.

Perhaps the most enduring legacy of the early farmers is traditional and structural. An attractive aspect of the new way of producing food was pastoralism, the keeping of herds. It was versatile. For example sheep could be milked, clipped, killed and eaten and all sorts of items could be made out of their horns and skins. Pasture, its preservation and the rights to it were the key and in the summer the hills in the south of East Lothian rang with the bleat and lowing of many animals. Each spring the upland journey of transhumance was made, from what was known as the wintertown to the summertown. The idea was simple; to allow the low-lying grassland the summertime to recover from the months of mud, rain and cold and send the

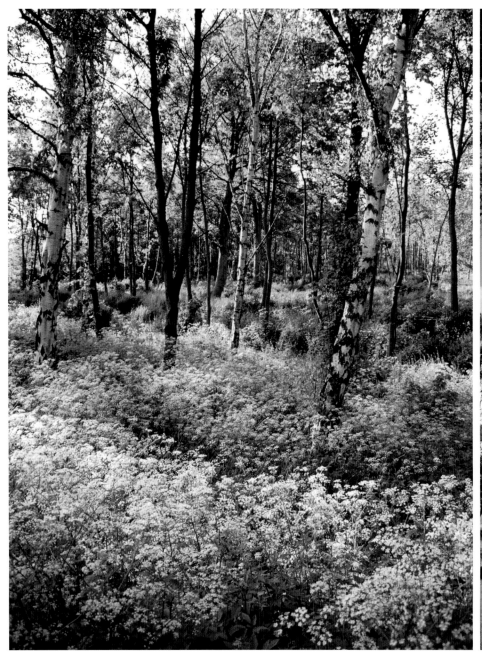

FARMLAND SOUTH OF GULLANE

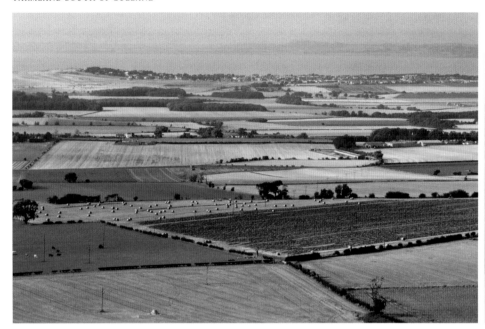

HADDINGTON

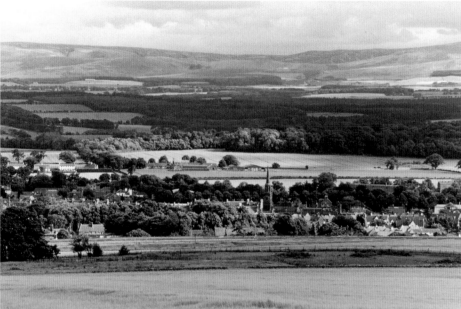

44

VIEW FROM HOPETOUN MONUMENT

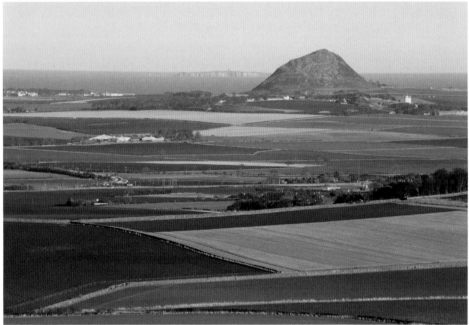

FOOTHILLS OF LAMMERMUIR HILLS

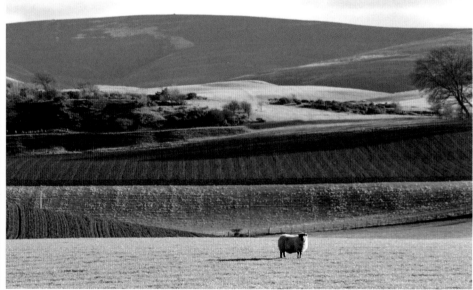

flocks and herds into the hills where the grazing was good and untrammelled by the winter's depredations.

The old parish and common boundaries remember the annual migration and, for example, Dunbar's moor or muir is well to the south of the town, up in the hills. Several parishes both to the north and the south of the Lammermuirs are oblong in shape as they stretch up to include the summer grasslands. The name of the hills is itself eloquent. Lammermuir means the Lambs' Moor and there is a ninth century document which talks of the Lombormore and another of the Lambremor. The hills themselves tell the same story – Lammer Law, Lamb Hill, Wedder Law, Hog Law.

At St Germains near Tranent more aerial photography showed up a prehistoric settlement. This was a farmstead (it still is) and archaeologists found evidence of new ideas and perhaps new people. What is known as beaker pottery was used in burials, perhaps as vessels for ritual meals, both food and drink. Metalworking was introduced in the second millennium BC, about the same date as the occupation of St Germains and the use of bronze became more and more widespread.

In 1,159 BC another cataclysm burst over north-western Europe. An Icelandic volcano called Hekla blew itself apart in a stupendous explosion, so stupendous that the distant, thunderous rumble could have been heard in north-west Scotland. Another tsunami raced towards Britain, funelling down the North Sea, trailing destruction in its terrible wake. But the giant wave was only a prelude. The eruption of Hekla had sent millions of tonnes of ash and debris rocketing high into the atmosphere. The prevailing wind blew the ash clouds eastwards, accelerating as they became more buoyant. When they reached the landmass a dense black rain fell in the half-darkness. The sun was completely screened by a deadly aerosol of condensing water vapour, volcanic dust and sulphuric acid. Extraordinary thunderstorms rent the air as the massive clouds collided. Lightning crackled and the sky boomed and roared. Those watching must have believed that the gods were at war, that the world was ending in an elemental agony of darkness and foul rain.

For many it did end. The volcanic winter created by the eruption of Hekla lasted a generation. Analyses of prehistoric tree-rings show that the sun was screened for 18 years. There were no summers, nothing grew properly, there were no harvests to gather in. Once food stores ran out, famine gripped the land with perhaps half of the prehistoric population perishing. Endless rain fell and peat began to blanket the landscape. Migrations from the west of Scotland all but emptied what had once been a hospitable and fertile Atlantic coastline and refugees straggled over the mountain

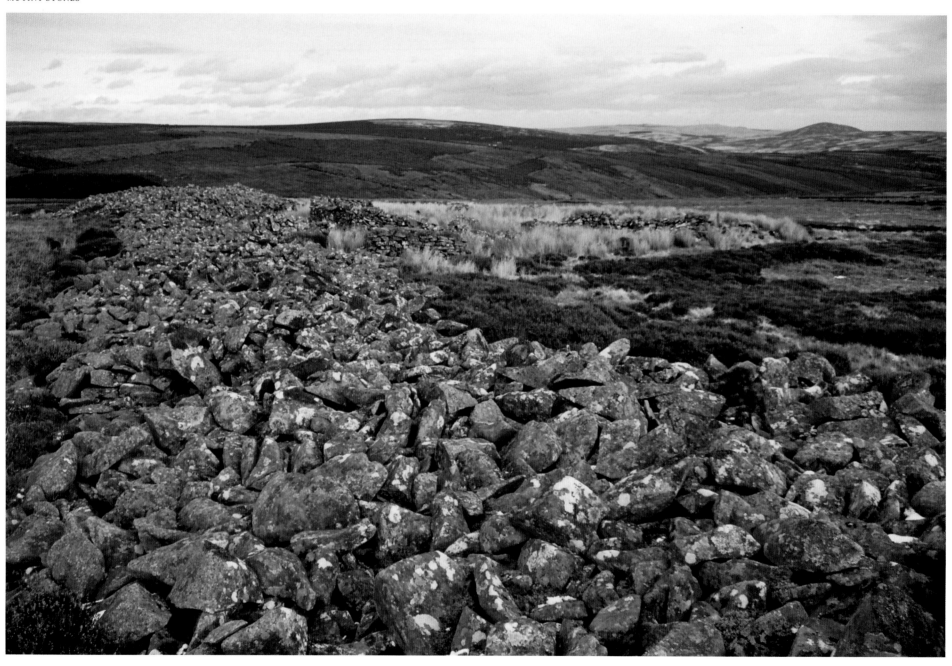

48

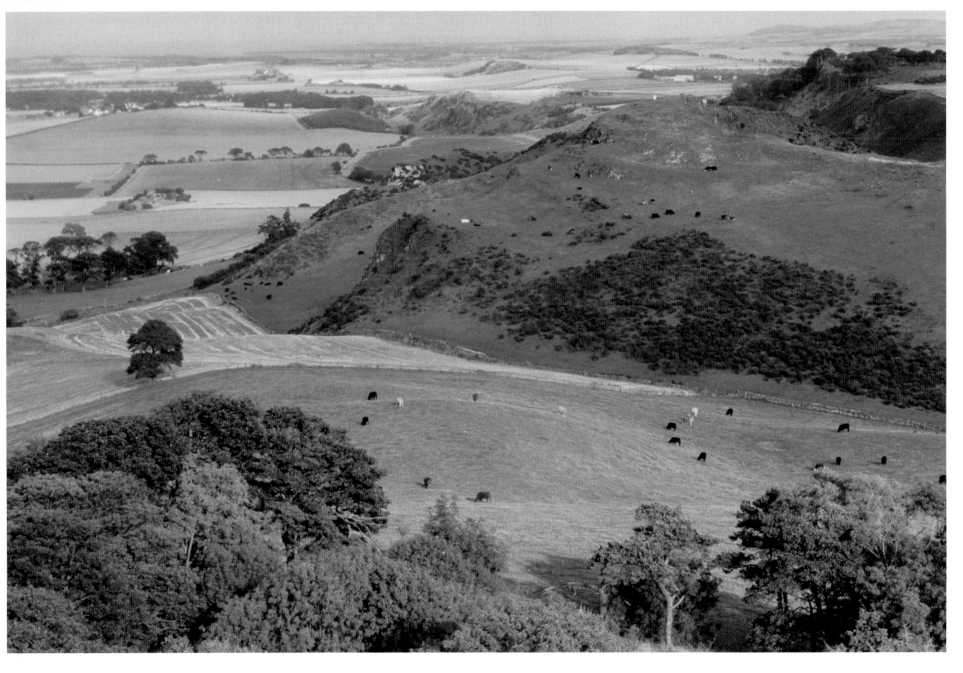

passes to find places to live on the eastern flatlands.

At St Germains, at Broxmouth Hillfort, at Dryburn Bridge near Dunbar and at Fishers Road in Port Seton, there is evidence of a reaction to all that misery. The archaeological picture is blurred and complex, but after Hekla settlements generally became enclosed and defended, often by ditches and timber palisades driven into the upcast. Precious livestock had to be protected, and so did its owners. Aerial photography has picked out the details of a divided landscape of field boundaries with their long banks and ditches. Great labour was expended in being emphatic about who owned what, and there is an unmistakable sense of dark times descending over a more fearful society.

East Lothian came to be dominated by hillforts. Some, like Traprain Law, were built on spectacular sites, others, like Chesters Fort near Drem, were raised at low-lying places. What they all share is a similar method of construction. Hillforts were formed by spade and pickwork as gangs dug out ditches, shovelled the spoil into baskets and piled it up on a rampart which was usually then topped by more defences, a palisade of wooden stakes or several courses of stonework or turf.

Despite all this back-breaking work, the builders were almost certainly not constructing forts. Many of the sites are either too large with very long perimeters (Traprain's is more than a kilometre) or too awkwardly sited to be effectively defended. The fort at Drem is even overlooked by a higher ridge from which attackers could easily rain down a hail of missiles. The perimeter at Traprain would have required a force of many hundreds to man the ramparts, and even though it could be argued that such a commanding site does not need much defending, there is no reliable source of water. Attackers could have camped at the foot of the law and waited for a starving and thirsty garrison to surrender.

The hillforts of East Lothian and of Scotland were more likely aristocratic and religious enclosures. The ramparts encircled centres of power and perhaps spirituality. The important thing for a magnate of the first millennium BC (and certainly since then) was to show who was boss, and a well-placed and impressively designed and palisaded hillfort made that statement unequivocally. It was the show that counted, and the reality of power behind the show.

And perhaps the gods were there too. In the 21st century we make a distinction between spritual and temporal, between religious and secular, between Sunday and the rest of the week. For most of the long history of western European society this was meaningless. The prehistoric peoples of East Lothian lived their religion every hour of every day, and if a hillfort housed their leader, he (or she) might also have been their high priest, the person through

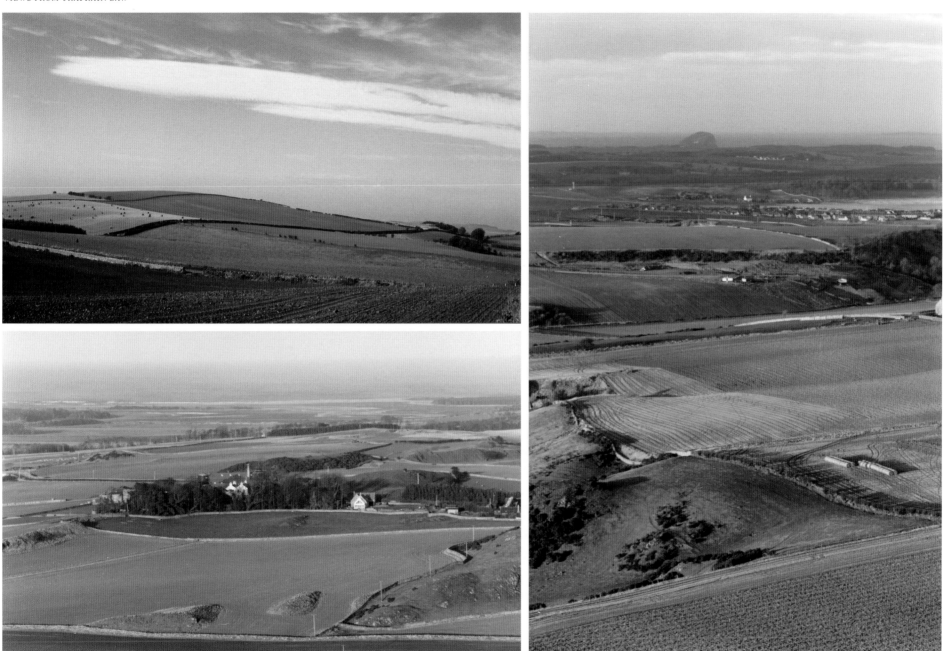

whom the gods made their purposes plain.

The idea of a sacred enclosure is very old, and very durable, reaching right into the Christian era and persisting even now. Perhaps hillforts delineated the holy ground, the sanctum sanctorum, a setting for ritual and for mystery. What actually happened is impossible to know, but something of the background might be sketched in. For by the first millennium BC East Lothian had become a Celtic society.

Place-names remember the lost Celtic language of the prehistoric peoples. It was an ancient version of Old Welsh and echoes of it can still be heard in the landscape. Aberlady comes from Aber Llefadyn which means the mouth of the gurgling stream. There are many others. Gullane is from Y Collen, or the hazel trees, Dunbar from Dun Baer or the summit fort and Tranent means the settlement by the dell and the second part of Longniddry is from Nodref for new settlement. The name of Lothian itself is puzzling. Most toponomists agree that it means the land of Lleu, but apart from being a Welsh proper name, what does it mean? Who was Lleu? It may be that he was a god, a version of the widely revered Celtic deity Lugh. Other place-names incorporate him – such as Lyons in France, Leyden in Germany and probably London. There are those who would feel it only appropriate that East Lothian has a divine derivation.

Traprain Law was certainly occupied in 1000 BC and it was likely the base of a powerful warlord, someone able to dominate the surrounding plain. The fort on the law needed to be maintained and supplied by a fertile hinterland which could be readily taxed – probably in return for protection. And it was fertile, very densely settled and cultivated. The warriors on the Law could step up to their ramparts and look out over a landscape dotted with dozens of farms in the immediate vicinity and away in the distance on every side see the cooking fires of hundreds more. Around Haddington there was another concentration. Inside a radius of ten kilometres more than 60 high-status forts have been detected by aerial photography. These were enclosed by rings of elaborate ditching and banking, many not built on defensive sites.

Traprain appears to have been the regional centre, a prehistoric capital place. Its name is old, but oddly adjacent. Using a formula often found in Old Welsh place-names, it means the hill by the settlement at the tree. In the first millennium BC the people who lived around it knew it by a different name. To them it was Dunpelder or the fort of the palisades. In a document written in the 14th century the names are twinned in a chartour of Traprene and Dunpeldare by the Erle of Merche to Adam Hyeburn. In the centuries after it was written, Dunpelder slipped out of use as the old fort on

the law was forgotten. A modern usage has surfaced, and Dunpender Community Council may be a whisper of the glories of former times.

In 1919 archaeologists found a glittering treasure on Traprain Law. A huge hoard of Roman silver came to light; there were beautiful vases, cups and spoons but much of it had been cut up and battered into flattened, folded pieces. For a long time it was believed that this hack-silver was booty, which had been looted from the southern side of Hadrian's Wall and chopped up for distribution to a warband. Recent interpretations tell a more likely tale. The Traprain Treasure is by no means unique. In locations stretching from Ireland to Russia similar hoards have been found which also date to the fourth and fifth centuries AD. Buried or concealed beyond the boundaries of the Roman Empire, these were not caches of loot from cross-border raids but bribes, the price of peace. Payments were made out of the imperial exchequeur (probably improvised from local, provincial sources) to buy peace from the tribes and kingdoms which lay just over the frontier. Whoever controlled Traprain Law was indeed powerful, and was paid handsomely for services rendered to the Roman Empire.

Towards the end of the first millennium BC and certainly by the time the Romans invaded Britain in 43 AD, the peoples of East Lothian had a name. They were the Votadini, in Old Welsh the Guotodin, and later the Gododdin. This name is – sadly – not very informative and it means something like the followers/the people of Fothad. He or she was probably a divine ancestor, a being whose legend is long lost.

From Traprain, the Castle Rock at Edinburgh, and the huge hillfort at Yeavering Bell in North Northumberland, kings ruled over the Guotodin. There may have been several kings bound together in a federation, or a high king and two or more sub kings. In any event they were definitely a sufficiently coherent political entity to be able to strike and keep a diplomatic bargain with the Roman invaders. Divide and conquer was the well-understood imperial policy and when it came to the conquest of Britain and its patchwork of regional kingdoms, imperial military planners and their legions only marched into battle when they had to. Highly trained legionaries and auxiliaries were valuable and when control could be sensibly bought rather than fought for, it was much the prefered course of action. Archaeologists have found a wide range and quantity of Roman material on Traprain Law, certainly enough to suggest a long and profitable diplomatic relationship between the kings and the governors of Britannia.

Part of the bargain struck appears to have been non-intervention. No Roman military roads appear to cross East Lothian, no forts have been found and no

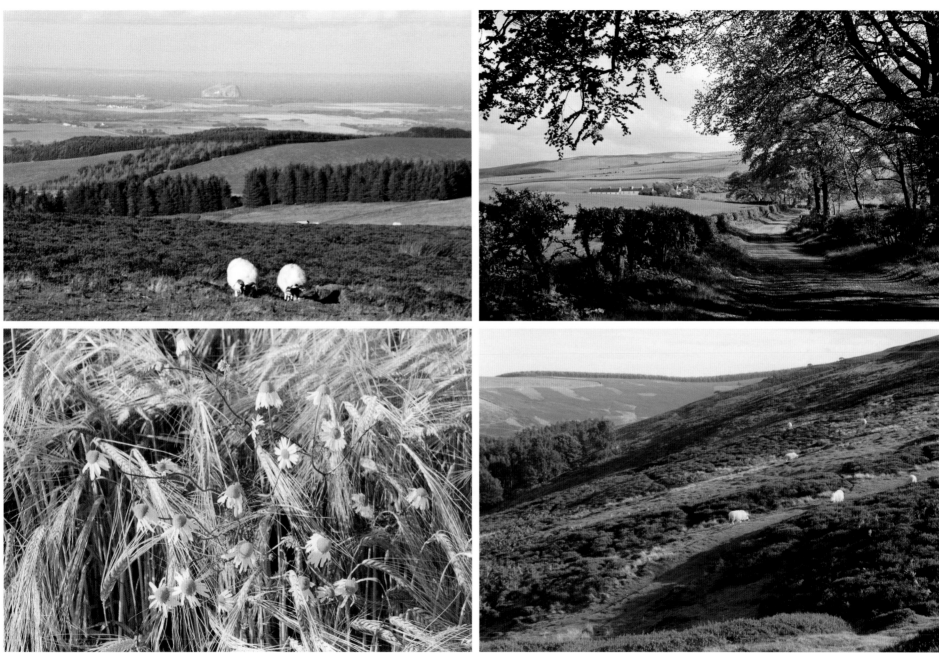

LUGHNASA

SAMHUINN

record of conflict in the area has come down to us. Only at Inveresk was there activity. Near the northern terminal of Dere Street, the great Roman military highway into Scotland, a cavalry fort was built, handily situated on the coast. The Classis Britannica, the British Fleet, could have easily supplied Inveresk. The site of the fort is now overlaid by a churchyard and the modern village, although in a private garden the remains of a hypocaust, an underfloor central heating system, can be seen.

Outside Inveresk fort was a substantial civil settlement known as a vicus. A street of shops, workshops, and other establishments led out of the east gate and it was likely the creation of native craftsmen and merchants anxious to profit from the arrival of the Romans. Hundreds of cavalrymen were garrisoned at Inveresk and they needed to buy what soldiers have always wanted; clothing, food, wine and women.

Entertainment of other sorts was also available; archaeologists have found the remains of a small amphitheatre.

The Romans did not make their way into a prehistoric landscape still blanketed by trees and peopled by primitives. By the first century AD and long before, East Lothian's wildwood had disappeared with only patches surviving where the ground was too difficult for farming or grazing. Iron had replaced bronze in the first millennium BC and iron-tipped ploughshares had changed the landscape. Farmers were able to cultivate wetter, heavier soils and expand the amount of land under crop. East Lothian grain was probably very attractive to Roman quartermasters and those kings who ruled over the farmers who grew it will have been treated courteously to ensure a reliable supply for hungry garrisons.

At Dryburn Bridge a good example of contemporary housing has been excavated. Made from circles of

timber posts securely planted in stone-packed holes, it was round and large, much larger than the average modern house in nearby Dunbar. The low circular walls were often built up from a few courses of drystone and the conical roof formed from thatch. There were no windows and the only sources of light came from the door, which was almost always placed towards the east to catch the morning sun, and from a central hearth. Roundhouses were snug and dry – and well organised. It is thought that there were two distinct areas for different activities and different times of day. In the northern half people slept and stored clothing and other items, while in the south meals were prepared and eaten and members of the family socialised when the weather was bad. Like crofting and cottar families on the farms of the early modern period, the people of prehistoric East Lothian spent most of their waking hours outside.

While the more enterprising drove their animals

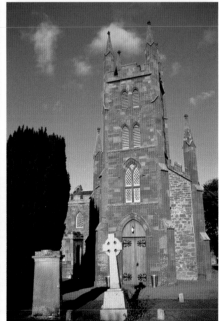

BEECH HEDGE BEAUTIFULLY SYMPATHETIC TO RED SANDSTONE OF WHITTINGEHAME KIRK

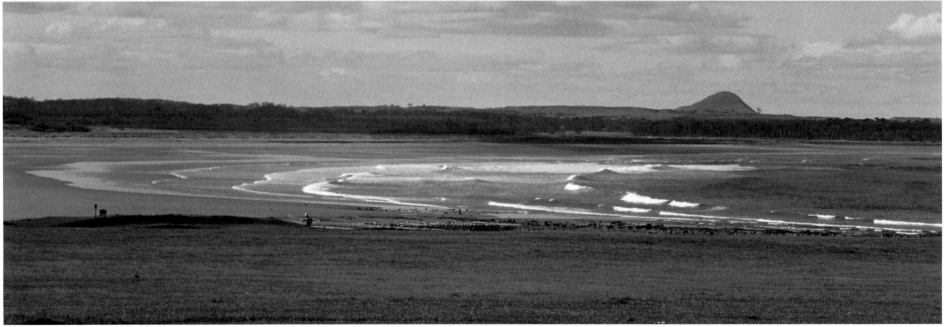

and carts to Inveresk to sell produce to the soldiers, all of the people of East Lothian probably gave part of what they grew and reared to their leaders. Up on Traprain Law kings looked out over their dominion. Their names are lost, the reach of their power uncertain but the society they ruled over is less shadowy. A Celtic language was spoken and its lexicon tells of the lives people lived. Four festivals were celebrated at the turning points of the year. Imbolc was in February and it marked the time when ewes began to lactate before lambing, producing the first milk of the late winter and a sign that its long nights were at last lightening. Then Beltane, now changed into May Day, saw the flocks and herds prodded along the upcountry trails, into the Lammer-muirs and the shielings, the summertowns. Lughnasa in August was the time of ripeness, the harvest, and Samhuinn is now remembered as Halloween in late October. The shortening days saw the shepherds bring their fattened beasts down to the wintertown.

Although these festivals revolved around farming and the stock-rearing year, they were also a time for ceremony, enjoyment and the exchange of news. Up on Traprain Law fires were lit, the king spoke to his people, perhaps the gods spoke to them all and they feasted, drank and danced – and probably also paid their taxes. Hillforts like Traprain, Eildon Hill North in the Borders and Yeavering Bell had room for large temporary populations, people who were summoned by their kings and their sky gods.

Remnants of the four festivals still survive in Ireland, and Beltane has even been revived recently on Calton Hill in Edinburgh. Roaring fires illuminate dancers, jugglers, musicians and an audience who come for fun and the outlandish spectacle. But in the long past the festivals had a political purpose. In the millennia before mass communication large and regularly timed gatherings were vital for those in authority. If kings and their officers wanted to lay down the law, levy tax, make war or announce an important item of news like a royal birth or death, they did it by telling their people to their faces – in the same place and at the same time so that there could be no dubiety. An attractive example of this ancient practice still happens at the annual Tynwald on the Isle of Man. Before they can be enacted, new laws must be spoken out loud by the Deemsters, now two bewigged and gowned lawyers. Towards the end of the first millennium BC people in East Lothian climbed up to Traprain Law to listen to the instruments of their government.

In the Celtic societies of that time government was of course autocratic, but a king or a magnate needed military backing and this came from his warband, a group of more or less professional warriors. Their role

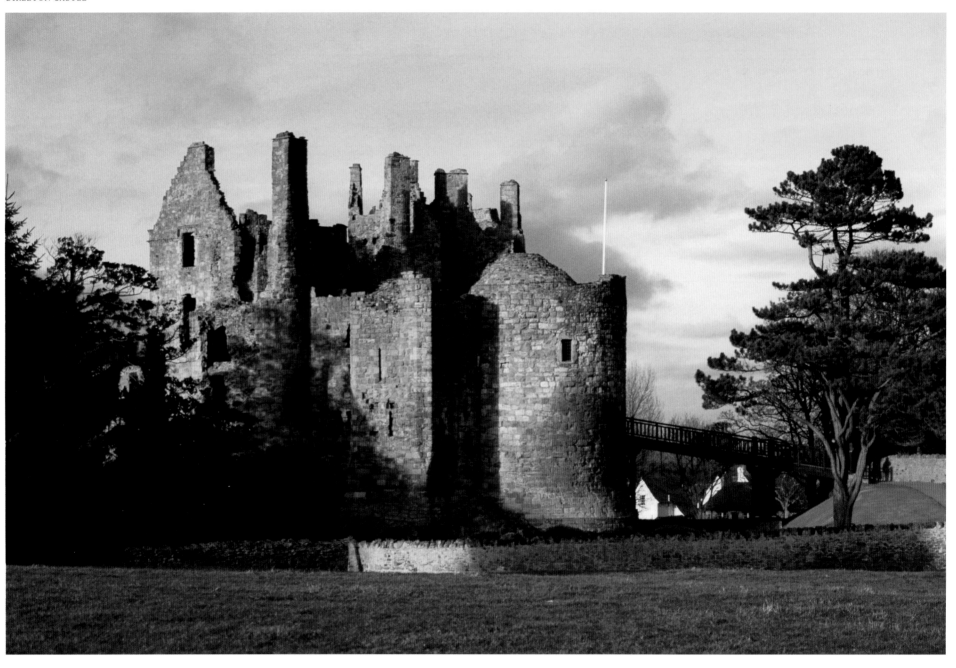

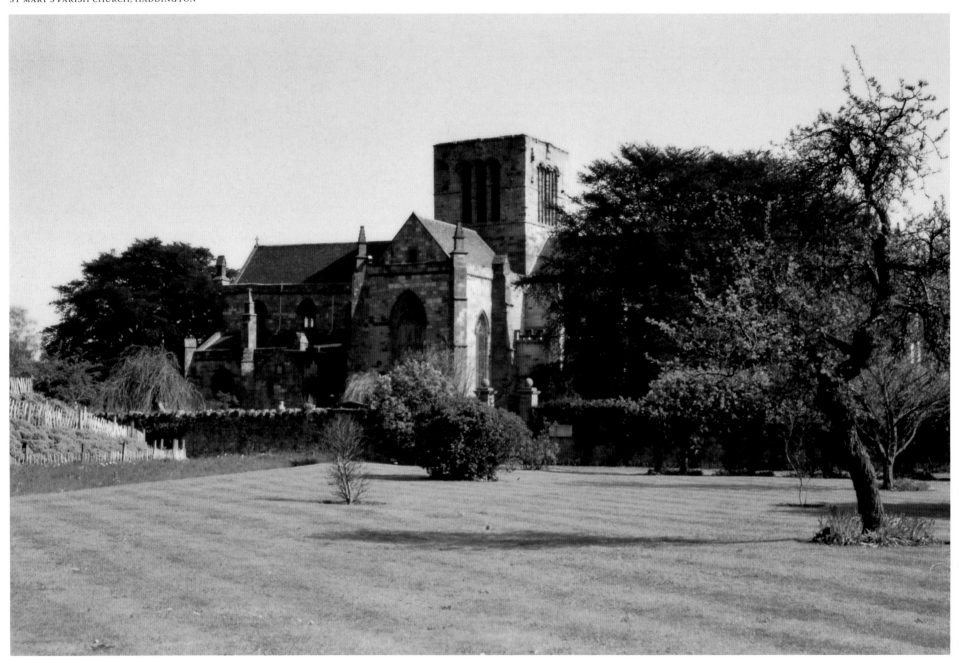

was simple; one of enforcement in peacetime and all-out aggression and leadership in war. Later sources talk of them as the teulu meaning family, and their leader as penteulu, literally, the head of the family. Contemporary archaeology strongly supports the notion that these men were cavalry troopers and also charioteers. Many metal rings known as terrets have been found and they were used as joining pieces for the straps of leather bridles and saddlery. When the Roman historian, Tacitus, described the battle at Mons Graupius in 83 AD, he saw charioteers racing about the battlefield but gives the impression that individual warriors dismounted to fight. Slightly later sources along Hadrian's Wall noted that the native kings commanded very many cavalry.

The warbands of the Guotodin were not tested against the legions of Rome. When Agricola, governor of Britannia, marched north into Scotland in 79, he was much more concerned about the Selgovae, the hillmen whose territory lay over the Southern Uplands. His diplomats having brokered a deal with the kings on Traprain, he could commit his two columns to a pincer movement around their hostile neighbours. By following lines roughly corresponding to the modern trunk-roads of the A74 and A68, his commanders kept the Selgovan kings pinned back in their hills as the legionaries tramped into Scotland. The two columns reunited at the Forth before pushing on towards the source of real opposition, the Pictish confederation.

Despite Agricola's success, the imperial government in Rome was ambivalent about Scotland. It was economically poor and, in the opinion of several contemporary commentators, scarcely worth the trouble and expense of conquest. But it was politically attractive. For emperors in need of prestige, the idea that their legions could march in triumph to the very limits of the world and force wild and strange peoples to acknowledge the greatness of Rome was a handy boast – something not even the great Julius Caesar or Augustus had managed. When Antoninus Pius succeeded Hadrian in 138, he gave instructions that the legions were once again to move north. There had been war in Britain and it may be that Antoninus' advisers believed that the recently completed wall of Hadrian had left their allies, the Guotodin, isolated beyond it. When the new Antonine Wall was finished and secured, they became part of the empire.

The inclusion of East Lothian was short-lived though. After Antoninus' death in 161, Marcus Aurelius withdrew the frontier once again to Hadrian's Wall. But it was not a successful or permanent retrenchment. War flared again in the north and native warbands crossed the wall into Britannia, killed a general and routed his legion. It is not known if the Guotodin took part in this expedition, but in any case trouble continued to

72

smoulder. Substantial bribes bought peace in 197 but in 207 war broke out again in Britannia. The Emperor Septimius Severus led the expedition himself. It was a huge army. Marching six abreast, the legionaries, auxiliaries and their baggage train stretched out for seven kilometres along Dere Street, a chilling sight for native scouts as they climbed through the Cheviots. When Severus reached the Forth at Inveresk he may have embarked an expeditionary force onto the galleys of the Classis Britannica and sent on the remainder of his troops by land. They secured the strategically vital cornfields of Fife, the territory of the Venicones. Known in Old Welsh as the Gwyngwn or the Kindred Hounds, they appear to have been allies of the Guotodin of East Lothian.

After a period of vicious guerilla warfare, the Pictish confederacy sought terms for peace. They were ultimately punitive, but the old emperor was too tired and sick to savour his triumph. In 211 Severus withdrew to the legionary fortress at York and there he died. Caracalla succeeded and acted immediately to evacuate from north of Hadrian's Wall. He must have believed the old man's expedition a great waste of men and money. The abandoned area, including the territory of the Guotodin, became a military buffer zone between the empire and the Picts. Scouts known as exploratores patrolled from forts just north of the wall. Caracalla's policy worked and for more than a century there was peace on the frontier.

In 367 a surprising piece of politics played out. Roman commentators called it the conspiratio barbarica or the Barbarian Conspiracy and it involved a concerted attack on the province of Britannia by an alliance of Scots, Picts, Franks, Atecotti and Saxons. It was successful. There was chaos as bands of raiders roamed the countryside looting and destroying. In 369 a tough and experienced soldier arrived in Britain to sort out the anarchy. Having declared an amnesty for deserters and reorganised a field army, Count Theodosius moved quickly north to secure the frontier. In the late fourth century the imperial army was much reduced, a more ad hoc entity than it had been in the glory days of the early emperors. Theodosius was short of a substantial frontier garrison and he made do with what he could find. In North Africa, the year before he came to Britain, he had attached squadrons of Roman cavalry to allied tribes on the borders of the empire, stiffening their ability to resist incursion. It looks as though he did something similar in southern Scotland. The Pictish confederacy north of the Forth were the constant threat and if the kingdoms between the two Roman walls could be turned into buffers, then the province might suffer less. The old kinglists hint at what happened. The Guotodin became known as the Gododdin and three of their early kings

had Roman names; Tacitus was followed by Paternus and he was succeeded by Aeternus. Even more interestingly Paternus had a nickname. It was Pesrut and it means the red cloak. Is this a reference to a serving Roman officer, someone put in place by Theodosius or a successor? Did the fourth century hack-silver discovered on Traprain Law represent a reward for keeping the frontiers of Britannia intact?

By the time the Roman Empire in the west fell, the Celtic kingdoms of southern Scotland had emerged as powerful entities. Gododdin was based around strongholds on the castle rocks at Stirling and Edinburgh, and at the hillforts on Traprain Law and Eildon Hill North. From the late sixth century bardic poetry (which survived in Wales) gives a strong impression of their culture. The Welsh called them the Gwyr y Gogledd, the Men of the North and talked of Yr Hen Ogledd, the Old North. Their bards sang of horse-riding warbands, of kings and warriors feasting and drinking mead in their halls before battle, of glory and of prowess. It was a self-consciously heroic society sounding more like the Iliad than the successors of the armies of the hard-bitten Romans. And it was a society whose glories would be short-lived.

The Gododdin and all of the Celtic kingdoms which emerged after the end of the Roman Empire were engaged in a bitter struggle, the war for Britain. From before the Barbarian Conspiracy Germanic warriors had been crossing the North Sea and serving as mercenaries – or attacking the province as pirates. In the fifth and sixth centuries more and more arrived. At Bamburgh an Anglian king called Ida began to rule in 547 and his dynasty became powerful, pressing hard on the Gododdin kings.

Bardic poetry remembers the battles and the battle-lines drawn in the war for Britain. By the end of the sixth century the Celtic kings rode out in the armour of the godly. All were Christians and all of their Germanic enemies were pagans. It was a struggle between the soldiers of Christ and the forces of darkness. The kings on Traprain Law called themselves Y Bedydd – the Baptised – and they did God's work when their warriors tore into the ranks of Y Gynt, the Heathens.

In 600 the war came to its turning point. A long epic poem of death-songs composed in Edinburgh in Old Welsh told of the last battle of the mighty Gododdin, their day of judgement. At Catterick in Yorkshire the allied Celtic army was cut to pieces by the Angles. Few survived and in the decades that followed, the Tweed Valley, East Lothian and Edinburgh were overrun.

Place-names trace the advance of the Angles into East Lothian. After the conquest was consolidated, they arrived in bands of settlers, almost certainly by sea,

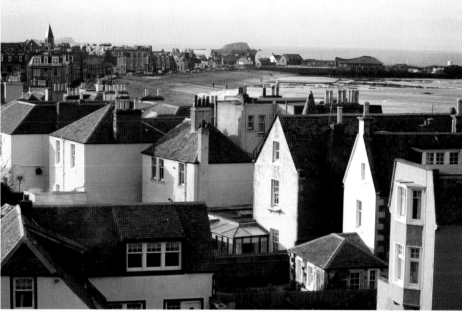

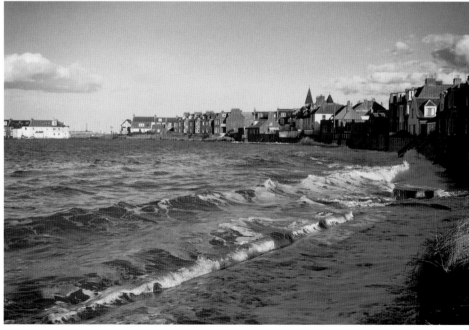

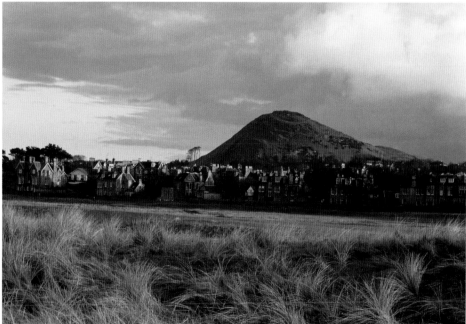

HIGH TIDE, NORTH BERWICK

VICTORIAN VILLAS ON THE EDGE OF BERWICK GOLF COURSE

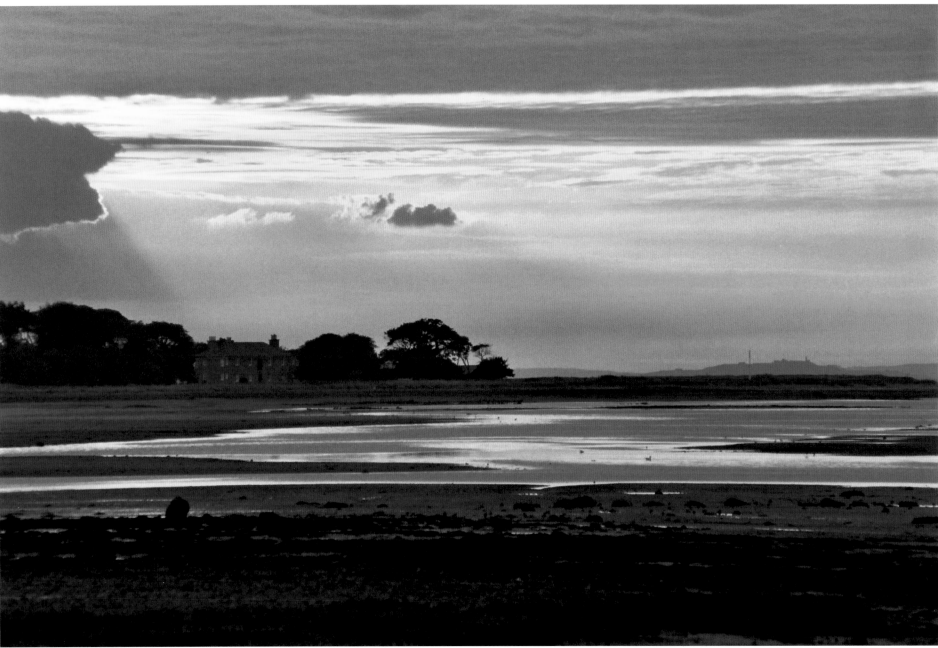

before making their way to parcels of prime agricultural land. The Anglian term ingaham means the settlement of the people of and over time a cluster of villages grew up near the mouth of the River Tyne. Foremost appears to have been Tyninghame, the settlement of the people by the Tyne. Nearby was Lyneryngham, the old name for East Linton, and it incorporated an Old Welsh word, linn, for a pool. And Whittingehame remembers the name of one of the new settlers. It was the settlement of the people of Hwita, perhaps a local magnate or simply a patriarch. Another important incomer left his name in Haddington which refers to the people of Hoedda. Ham place-names in East Lothian are also indicators of early Anglian arrivals – Auldhame, Morham and Oldhamstocks.

These new names are the deposit of takeover, but no record exists of the process. Were there skirmishes? Were native peoples driven out? Did migration take

place? No-one knows, but it is likely that events followed a time-honoured pattern. At Doon Hill, near Dunbar, archaeologists believe that they have found one of the very earliest Anglian structures in East Lothian. On the site of an earlier British fortress another was built in the first half of the seventh century. Its earthen ramparts were topped by a timber stockade and the speed with which it was thrown up is significant – was an Anglian warband establishing a makeshift base in a hostile countryside?

In the wake of the catastrophic Gododdin defeat at Catterick in 600 where many native aristocrats are said to have been killed, it may be that Anglian magnates, such as Hwita or Hoedda, moved quickly into a power vacuum, imposing themselves by force if necessary. As more settlers came north, they began to change the look of the landscape as well as its names. Unenclosed villages were laid out with frontages along a path or

street, sometimes an open space or a green, and with long cultivation plots stretching out behind them. Modern visitors from other parts of Scotland often remark on how English East Lothian feels and looks, and historically they are right. Even if the details of the transformation remain obscure, their instincts are good.

When the victors of Catterick entered the new landscape, their presence may have seemed doubly terrifying. Not only were they unknown aggressors, they were also pagans. The Gynt had come with their foul gods and would profane the community of Christ's people. And it does appear that East Lothian was devout in the early seventh century. Archaeologists have discovered the remains of 16 Christian cemeteries, their locations spread evenly over the northern flatlands. Some were very large. At the ancient settlement of Longniddry more than 200 stone-lined graves have been found and the remains in them carbon-dated from as

early as 480 to 650. And place-names support the sense of an early Christian society. Over southern Scotland the eccles element found in the likes of Ecclefechan, Eccles, Eaglesham and elsewhere denoted the presence of a very early and important church. Eaglescairnie was such a site, perhaps a mother-church overseeing a network of dependent chapels.

The Angles in East Lothian soon converted. After King Edwin of Northumbria was baptised at York in 627 his magnates and his people followed him into the church. It made every sort of political sense. As new masters in a Christian countryside, and in a precarious minority, the Anglian settlers were well-advised to blunt the edges of potential contention. When they worshipped the old pagan gods of Woden or Thor, they were aliens in a strange land. When they turned to Christ, it was as though the natives had won a spiritual victory after their secular defeat.

The Northumbrian kings and their noblemen were also pretentious. Christianity was inextricably associated with Rome and Rome was the template of power, the memory of the empire still strong. When the royal retinue progessed north into East Lothian (almost certainly coming to a stone-built hall at Dunbar) it was a grand, neo-imperial affair, at least when anyone was watching. The procession was led by a standard-bearer carrying a tufa, a winged orb of the sort popular in Roman cermonial, and the warband riding behind him had become the comitatus. Christianity was conducted in Latin, controlled from Rome, was somehow a successor of the empire, and its adoption fitted in well with the ferocious ambition of the Northumbrian kings.

They also found their own saint in East Lothian, or at least a saint with an Anglian name whose cult would become popular in the heart of the new settlements. Baldred is a misty, half-forgotten figure who is said to have been born at Auldhame, or perhaps in Strathclyde, in 607 and to have died in 756, aged 149. The landscape remembers him more accurately and near the mouth of the Tyne is a rock formation known as St Baldred's Cradle. Farther up the coast towards North Berwick is a singular, sea-girt rock called St Baldred's Boat, and onshore is St Baldred's Cave, and near Auldhame Farm, St Baldred's Well. Late medieval sources said that the saint founded monasteries at Tyninghame, Auldhame and Preston Kirk (where there is another St Baldred's Well only 50m from the church) and that when he died, each claimed the right to bury his body. In a miraculous solution, the saint multiplied himself in triplicate so that none were disappointed and all could be the focus of his cult. This is a good deal of geography for a legendary figure.

In May 2005 reports began to appear that the mists around St Baldred might be clearing.

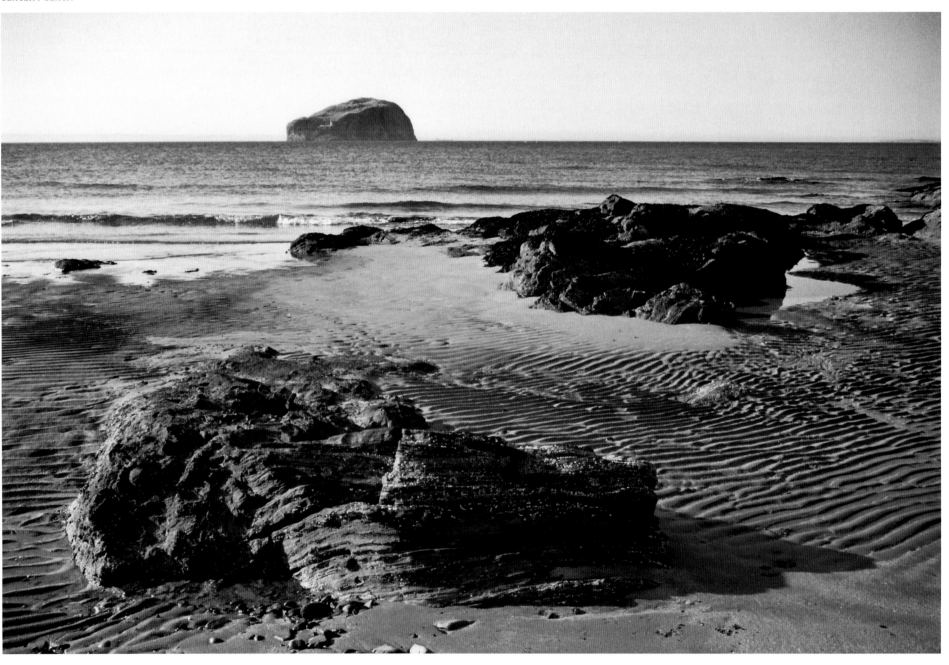

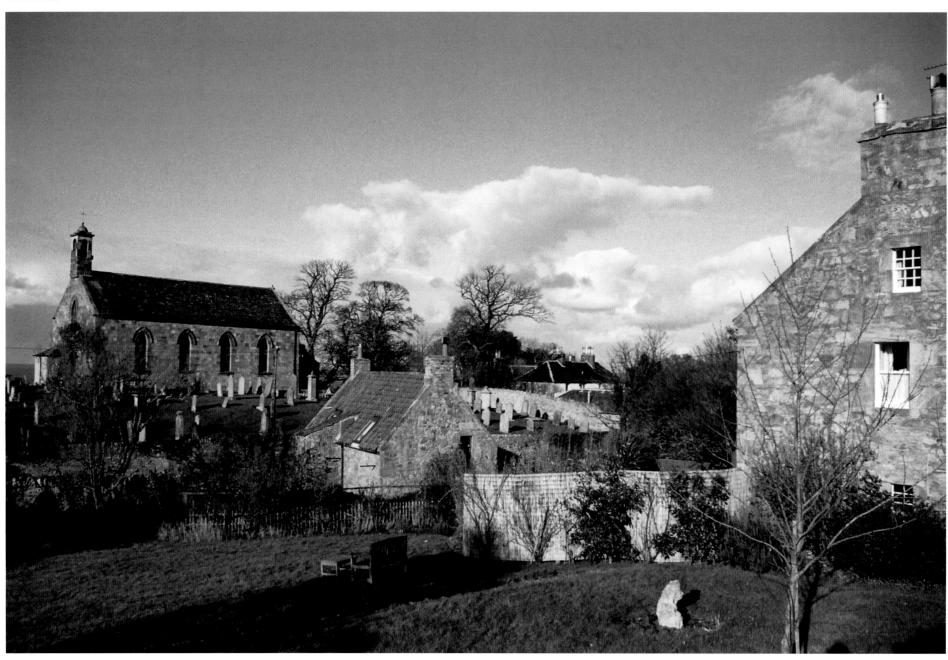

88

At Auldhame Farm what may well have been his church was discovered. With a possible date as early as the seventh century, within the realistic span of the saint's life, a building with rounded corners was excavated. This design is understood to be very ancient and around the little church was a cemetery with more than 200 Christian graves.

The location of the old kirk was also eloquent. It sits near the rocky coast in the midst of all those Baldred place-names and looks directly out to sea at the Bass Rock. There is a powerful tradition that the saint built a hermit's cell on the Rock and indeed there exist medieval ruins known as St Baldred's Chapel which may incorporate the cell in the foundations. A final piece in the historical jigsaw is a persistent tradition that – despite his Anglian name – Baldred was a Celtic priest sent from the west by St Kentigern to convert the heathen Angles of East Lothian.

Perhaps it is all absolutely accurate. The archaeologists at Auldhame seem to have discovered elements of a sacred landscape, the centre of a highly localised and intense cult. To understand something of the sequence of Christian conversion, it is worth rewinding the story and the legends a little. Kentigern was certainly a Celtic holy man of tremendous stature. His name means First Lord and can be rendered in modern Gaelic as Ceann Tighearna. And although Kentigern gained great lustre as the saintly founder-bishop of Strathclyde, the medieval sources insist that his origins were in East Lothian, that he was conceived inside the royal compound on Traprain Law. A princess fell pregnant (clearly as a result of illicit sex, but Kentigern's biographer, a monk called Jocelyn of Furness, insists that the deed happened while the princess was somehow unconscious, perhaps even drunk, and that therefore it shouldn't have counted against her) and her dastardly

pagan father, the king who ruled on Traprain Law, condemned her to be thrown off the cliffs on the south-eastern edge. Instead of being smashed to death on the rocks below, Thenu prayed to the Virgin Mary for a soft landing. After which she was cast adrift on the sea in a coracle – only to wash ashore at the monastery at Culross on the northern coast of the Forth where she gave birth to Kentigern.

This tale has an umistakable Celtic atmosphere and may contain shreds of history, the likelihood being that the disgraced Thenu was banished to a distant monastery to have her illegitimate child out of sight and out of mind. But Kentigern remembered his miraculous beginnings, wrote Jocelyn, and he sent Baldred to convert the Angles of East Lothian and found his churches, which it now appears he may have done. And like St Cuthbert and many Celtic hermit-monks Baldred found spiritual peace in the midst of the deserts

of the sea, on the Bass Rock. He probably predates Cuthbert and St Aidan by some distance and as archaeology fills out his historical presence, Baldred might be seen as one of the very earliest of all the missionaries from the west who brought the word of God to the Gynt. He also appears to be a transitional figure, a bridge between the Celtic and Anglian churches. The cult lasted well into the middle ages and a feast of St Baldred was celebrated for many centuries in East Lothian on March 6th.

In their new territories the Anglian settlers reorganised the church. A parish system was set up with many of their villages at its centre – Auldhame, Tyninghame, Haddington and East Linton amongst them. And it is notable that several of the early and large Christian cemeteries such as the one at Longniddry ceased to be used around 650. The church at Whittingehame was dedicated to Oswald, the Northumbrian king who was canonised in the seventh century. As time went on the Celtic character of East Lothian was submerged. Old Welsh shrank back into the hills and remote places and what became English was spoken in the fields, farms, villages and churchyards.

◆ ◆ ◆

In 793 a storm burst over the eastern coastline of Britain. 'Fiery dragons were seen flying in the air, and soon after in the same year the harrying of the heathen miserably destroyed God's church in Lindisfarne by rapine and slaughter.'

The Vikings had sailed out of the sea-mists and into history. In the decades after the attack on the shrine of St Cuthbert they raided East Lothian, and beaching his longships on Tyne Sands, a sea-lord and his warriors surprised the priests at St Baldred's monastery at Tyninghame and destroyed it. It lay dangerously close to the shore, in what became the policies to the south-east of Tyninghame House. Later raids were precisely timed to make landfall when Christian festivals were being celebrated. Sea-lords knew a great deal about the workings of the church and that all the treasures of a monastery would be displayed on the altar at Easter and saints' days such as St Baldred's and not hidden away in a secret bolt-hole.

As with the Angles, Viking settlement followed upon military action and place-names record where. The second element in Humbie derives from byr, a Norse word for a farm, and the use of haven in Belhaven and the obsolete Lamerhaven (for Dunbar harbour) is also characteristic. North Berwick was not, and it is unlikely that the other wick names in East Lothian were either. A wick was an outlying farm attached to an ancient shire and North Berwick was the northern barley farm

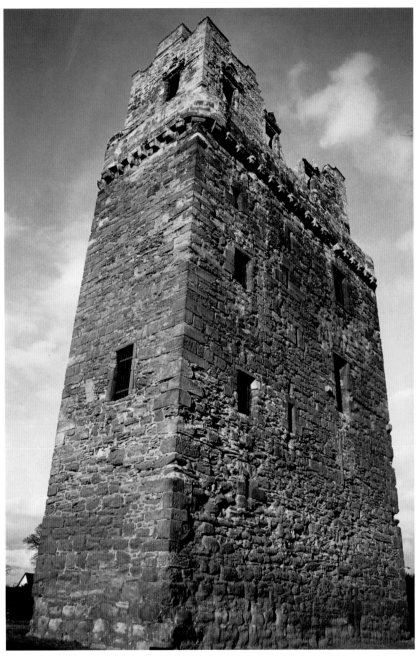

94

probably belonging to Haddingtonshire. Up until the early 20th century maps of Scotland did not mention East Lothian and noted only Haddingtonshire, a much expanded version of the nucleus.

The extent and severity of the pressure exerted by the Vikings is hard to gauge, but they certainly slackened Northumbrian political influence considerably. And there was competition from the west for control of the fertile cornfields of the coastlands. Since the early years of the seventh century when they fought a losing battle against the advancing Angles near Lauder, the Gaelic-speaking kings of Argyll had been steadily spreading their power over the rest of Scotland. As every schoolboy (and girl) used to know, Kenneth macAlpin was the first king of Picts and Scots by his death in 858. Even though he was in reality one of the first, all Scottish kings are numbered from him. His successors had been pressing eastwards ever since, the opposition coming not from the Northumbrians but the Viking kings of York. In 973 the dominant power in England, Edgar King of Wessex, formally recognised the takeover of East Lothian by the Argyll dynasty. They had begun to call themselves Kings of Alba, still the Gaelic word for Scotland. Their arrival is remembered here and there in place-names. Balgone and Ballencrieff show a typically Celtic word-order in the use of the Gaelic baile for settlement. But it is very unlikely that many people adopted the language of the Alban court and they continued to speak an early version of English at their hearthsides and in the fields.

The macAlpin kings were eventually replaced by the macMalcolm dynasty and in 1018 Malcolm II summoned his host to muster at the Caddon Water near Galashiels. Owain, the last king of Strathclyde, was there and many other magnates came from the north with their warbands. Waiting for them by the Tweed at Carham, below Kelso, were the spearmen of Northumbria. It was a bloody fight, the north triumphed and macMalcolm power crept southwards. The battle at Carham is often represented as Scotland vs England – and for once we won – but that is to misunderstand the dynamics of medieval politics. The English-speaking peoples of the Tweed Basin and East Lothian were culturally very much closer to the Northumbrian spearmen than to the Highland warriors who cut them to pieces. But nevertheless south-east Scotland had reached its modern extent by the 11th century and the frontier would never move north to the shores of the Forth again.

National frontiers though were a thing of the future. The reach and power of kings were what mattered and these were measured in relationships and bonds of loyalty backed up by the possibility of military action. Great magnates were neither particularly English

TANTALLON CASTLE

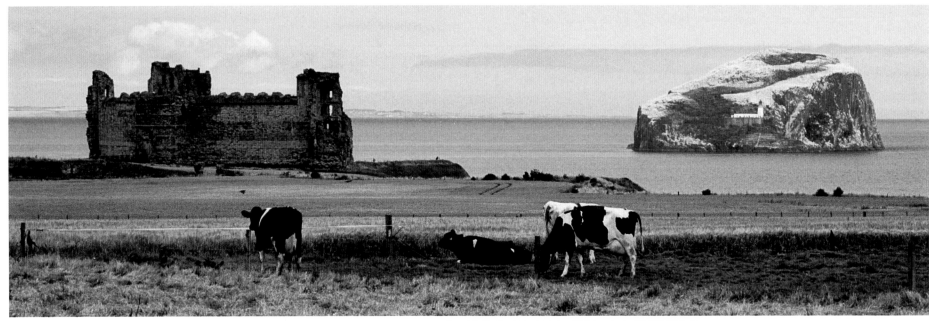

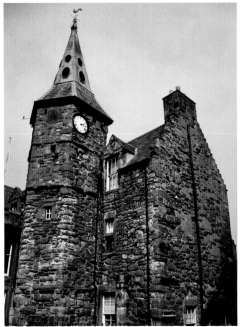

TOLBOOTH, DUNBAR

WHITEKIRK CHURCH

nor Scots but rather bound to a macMalcolm king, a York king, or a Wessex king. Gospatrick, Earl of Northumbria, found himself torn at least three ways at once. When William the Bastard fought his way into England and onto the English throne in 1066, Earl Gospatrick was not disposed to support him. At the same time it appears that he held lands in the Tweed Basin and in East Lothian which were firmly in Malcolm III of Scotland's sphere of influence and action. And before all of that, Gospatrick had a primary loyalty to his own interests and those of his family.

What happened in 1072 and for decades afterwards shows glimpses of how the ancient territory of the Gododdin and its successor kingdom of Bernicia (the more northern province of the kingdom of Northumbria) had retained some of its shape and coherence. When William the Bastard successfully deposed Gospatrick from his earldom of Northumbria,

it seems that he removed him from only part of his lands. Malcolm III created him Earl of Dunbar but this was probably only a formal recognition that Gospatrick already held extensive lands in that area and that all the Scottish king was doing was reinvesting him with the title of earl. The site of the prehistoric fort at Din Baer, and of the old royal hall of the Angles, was chosen for the seat of the earldom.

More than kindness to an aristocratic refugee, this initiative from Malcolm was aimed at claiming all of the old lands of the Gododdin/Bernicia for the Scottish crown and a great magnate. Malcolm III also laid a foundation stone for Durham Cathedral and its famous shrine of St Cuthbert. He was killed fighting in Northumberland in 1093. Duncan II granted the church at Tyninghame to Durham and in 1104 Alexander I was the only layman present at the opening of St Cuthbert's tomb. In the early middle ages East Lothian, the Tweed

Basin and Northumberland seem to have been thought of as a unified political and cultural entity. The old parliamentary constituency of Berwickshire and Haddingtonshire was a faint echo of this.

As land south of the Tweed gradually drifted under the influence of English kings and earls, Gospatrick and his sons settled to the task of establishing their patrimony in East Lothian and what was becoming Scotland. The atmosphere around them is intriguing. From Gwas Padraig meaning the servant of [St] Patrick, Gospatrick is an Old Welsh name. With only one exception the first eight earls of Dunbar used it. Was it a self-conscious harking back to a Celtic past when their lands were much more extensive? At the end of the 13th century their household was entertained and commemorated by a famous bard who recited poetry of his own composition and chilled his audience with fell prophesy. Thomas the Rhymer lived at the town and castle of

KALE

PLOUGHED FIELD

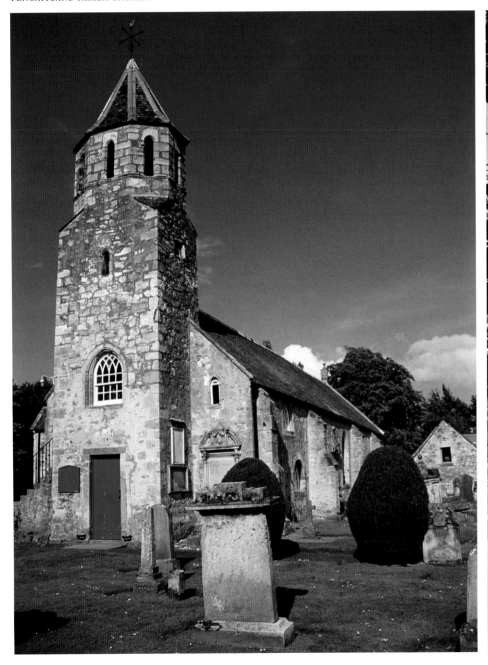

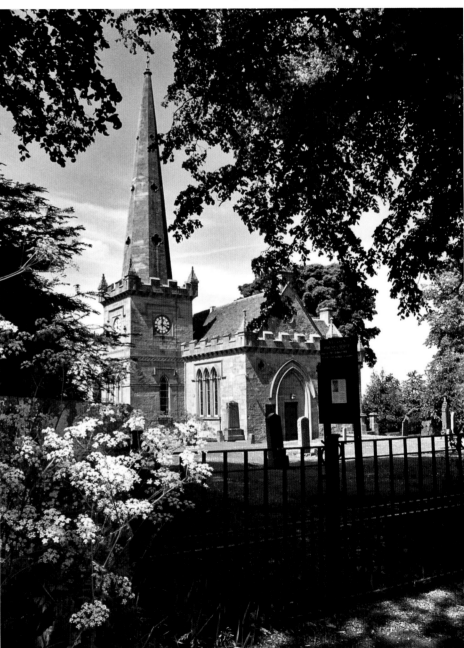

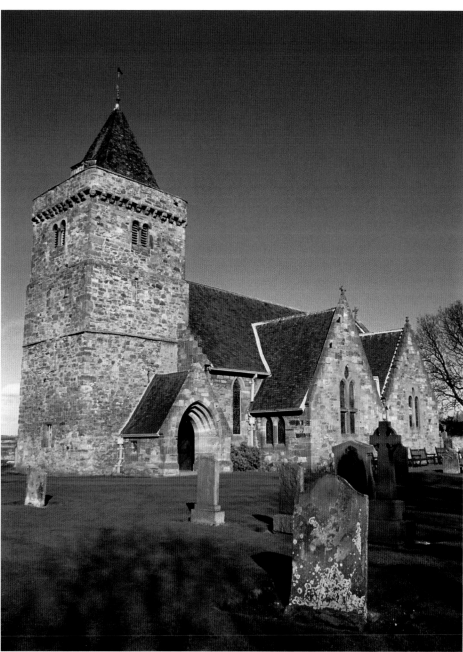

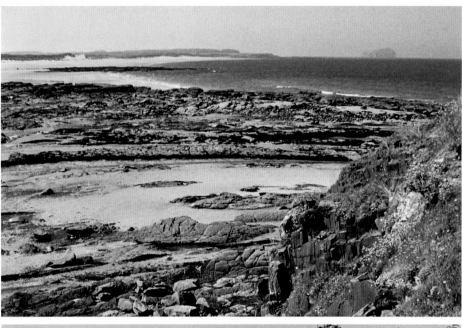

FUSCHIA HEDGE, GULLANE

CORN MARIGOLDS, BYRES

Earlston, a Dunbar property, and was no doubt welcomed into their hall.

As the Norman conquest of England consolidated, new people came to East Lothian. David I of Scotland had been raised at the Norman court of Henry I of England and he saw the operation of the new power politics at first hand. In return for grants of land, Norman French friends of the young king came north and promised to support him. The de Vaux family built a motte and bailey castle at Dirleton, making full use of a handy rocky outcrop. The village grew as nearby Gullane was threatened by the encroachment of sand dunes.

The early earthen banks and ditches, and the stockade, were all replaced by a stone-built castle around 1225. From then on it featured as an important and impressive fortress in the ebb and flow of history as it washed over the landscape. Forced to surrender in 1298 to an invading English army, Dirleton was retaken by King Robert the Bruce in 1311 and probably partly destroyed to prevent it being of use to more English enemies. East Lothian had the geographical misfortune to straddle a major invasion route from the south and suffered regularly as a consequence. In the 14th century Dirleton Castle was controlled by the all-powerful Douglases, then by the Halliburtons and for a long time by the Ruthvens. By 1663 it had been purchased by John Nisbet but he left it to decay while work began on a smart new house at Archerfield.

Some time between 1124 and 1153 David I made Haddington into a royal burgh. All sorts of rights and privileges accompanied the grant and it seems that kings and their courts were visitors. On the site of the council buildings on Court Street it is said that there was a royal residence and that two kings were born in Haddington, Alexander II and William the Lion.

Like other royal burghs Haddington was designed to make money for the king and for its merchants. Towns were very small in medieval Scotland and the vast mass of people lived on farm places in the densely cultivated countryside. Haddington held frequent markets selling products of all kinds but a prime function was as a processing centre for animals. Sheep, cattle, pigs and goats were driven to the town and shorn, or killed before being butchered, preserved and having their hides tanned or their horns made into various items such as tableware.

Less prosaically, Haddington had a grammar school in the 13th century and its most illustrious former pupil was said to have been John Duns Scotus, one of the greatest European philosophers of the middle ages. Berwickshire people take a different view, believing that he got his schooling at the Franciscan Friary in Berwick-upon-Tweed.

Franciscans usually prefered to locate their churches outside the walls of medieval towns – somehow to keep them apart from the tumult of the world. By the 14th century St Mary's had become one of the largest churches in Scotland, a sure sign of Haddington's wealth, and it had gained a romantic description as the Lamp of Lothian. It burned down in 1356 but was rebuilt on a similar scale. The name of the Lamp of Lothian transfered to the town itself, and has stuck – and developed into the Lamp of Lothian Trust.

Tourism came early to East Lothian, but it had nothing to do with buckets, spades and ice-cream and everything to do with salvation and damnation. Pilgrimage brought visitors from far afield to Dunbar and especially to North Berwick. In the 1150s Duncan, Earl of Fife, gave money to set up a ferry service from North Berwick across the Forth to Earlsferry. In the 11th century Queen Margaret had done something similar between South and North Queensferry. The final destination was St Andrews and the relics at one of the greatest shrines in western Christendom. St Andrew had been with Christ as an apostle, and was the brother of St Peter, the founder of the Church in Rome. The cult and its relics were an enormously powerful magnet, drawing pilgrims from all over Britain. The establishment of the ferry at North Berwick changed an outlying barley farm with a harbour into a thriving settlement. At its height, pilgrimage brought 10,000 people a year to the town.

Earl Duncan founded a house of Cistercian nuns who managed the ferry and both of its terminals. They had a hospice or hostel near North Berwick harbour to house pilgrims and ran a lucrative trade in souvenirs. These were mainly pilgrim badges which carried images of St Andrew and his cross. Moulds have been found showing that manufacture took place in North Berwick. The badges were also useful because they protected pilgrims to some extent, indicating what they were and where they were bound. Dunbar was also a stopping-off place and a house of Trinitarians was established to cater for the passing trade. At Haddington one of the largest Cistercian nunneries in Scotland may also have housed pilgrims on their way to the ferry.

Those passing through East Lothian probably took in St Baldred's shrine at Tyninghame and almost certainly visited Whitekirk's curative well, dedicated to the Holy Mother. Towards the end of the middle ages it overshadowed Baldred's cult and both James I and James IV came to take the waters. In 1971 the Earl of Lauderdale revived pilgrimage in the county. On the second Saturday in May there are services held at Whitekirk, Lennoxlove and St Mary's Haddington. Thirty people went on the first pilgrimage and now more than two thousand attend.

International politics cut a deadly swathe through East Lothian in the 1290s and for almost three centuries afterwards. As Edward I of England attempted to assert himself in Scotland, armies tramped across the landscape, stealing, burning, terrifying and killing. Farms, churches, castles and towns were burned to the ground as Wallace, Bruce, Edward and his son struggled for control. In the early years of the 14th century all that misery was made much worse by the onset of climate change. What historians call the Little Ice Age began – and it lasted intermittently until the mid-19th century. In 1315 and 1316 it rained incessantly in the second half of the summer, so much that crops rotted in the fields and there was no harvest to speak of. Bad years followed and famine devasted the countryside as much as the kings and the armies who fought over it.

War rumbled on. In 1333 a Scots army was destroyed by Edward III and his archers at Halidon Hill outside Berwick-upon-Tweed and five years later another invasion force made its way north. The Earls of Salisbury and Arundel laid a seige to Dunbar Castle. The Earl of Dunbar and March was absent but the defence rallied heroically under the command of his wife. Known as Black Agnes because of her colouring, she mocked the attackers by dusting off the walls with a kerchief each time a cannonball scored a hit.

More devastation waited as the dismal 14th century wore on. The pandemic known as the Black Death reached Scotland in 1349, probably making first landfall at the southern ports of Berwick, Leith, North Berwick and Dunbar. Death was agonising but fast. After the symptoms appeared, usually swellings in the groin known as buboes, fever consumed victims within 36 hours. So many died so quickly that the normal offices of the church had to be suspended. Extreme unction was rarely given and families were discouraged from sitting at the bedside of afflicted relatives. It was a lonely and excruciating death.

The population fell dramatically. At the time of the first outbreak in 1348 England was a nation of seven million souls, but by 1400 only two million had survived. In densely settled East Lothian, and especially in the small towns, it is likely that more than half the people died. Plague visited many times in the 14th and 15th centuries and there were at least three deadly variants; bubonic, septecaemic and pneumonic. It was difficult to escape infection and every family suffered loss.

An immediate effect was spiralling economic decline. Suddenly there were too few to cultivate the fertile rigs of East Lothian and tend the flocks and herds as they were driven up to the summer pastures on the Lammermuirs. The balance of power in society shifted a little as scarce agricultural labourers were able to strike better bargains with lairds.

III

Farming took a long time to recover from the effects of climate change and the Black Death. But alternative food sources, such as fishing, were unaffected and the inshore catch swam in the Firth of Forth for anyone with the skill to exploit it, and the herring spawning grounds were close, running from Berwickshire down to Sunderland. Religious dietary requirements (which were a great deal more onerous and complicated than fish on Fridays) had long ensured a steady market for what the fishermen of North Berwick, Dunbar and the smaller seaside villages could land. Musselburgh had Edinburgh to supply, the fishwives of Fisherrow able to carry their creels right into the heart of the city. Fresh fish from East Lothian was carried much longer distances. From Dunbar across the Lammermuirs to Lauder in the Borders ran the old Herring Road. It was travelled by young and fit men who carried creels of fish far inland and it is said that in the summer heat they ran in case their load spoiled. Perhaps they did. And perhaps the more sensible used pack-horses.

Coal mining in East Lothian began very early and always had strong links with the fishing. Since a time out of mind coal had been picked up on the beaches of the Forth and until the late middle ages it was known as carbo marinus. Sea coal was used industrially to heat seawater in wide iron pans to make salt, which in turn was vital for the preservation of fish and butchered meat. Prestonpans got its name from salt-panning. And Salters' Road still runs from Newbattle through Whitecraig and Wallyford to Prestonpans. Lime was the other major product made possible by coal. It could be burned into a powder in kilns, many of which are still visible in the landscape, and it was used in builders' mortar, in bleach and ultimately as a fertiliser.

The earliest record of coal mining in the whole of Britain relates to East Lothian. The de Quincys, a Norman family imported by David I, granted to the monks of Newbattle Abbey the right to dig coal from their coal-heugh at Whytrigg near Prestonpans. A heugh or cliff was a place where the coal seams were visible and workable from the surface, but as more was extracted the miners were forced to dig downwards and create pits. These became dangerous as they deepened, often flooding and collapsing.

Sea coal was not popular as a household fuel, certainly amongst the better-off. It was thought to give off noxious smells and wood was preferred for both heating and cooking. But timber was scarce in the medieval period and coal could be won from many seams in the Lothians. The coalfield stretched from the coast at Longniddry (as well as under the Forth at Musselburgh) and across as far as Pathhead and it was dug in more than 350 places.

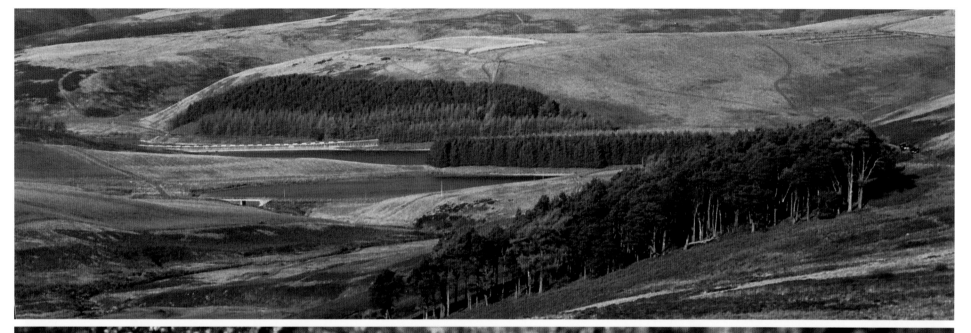

WHITE (MOUNTAIN) HARE, COMMON IN THE LAMMERMUIR HILLS

Cross-border warfare crackled on into the 16th century and Haddington in particular was often besieged, or occupied by an English garrison and several times well burned. In the midst of all this turbulence a boy grew to manhood in East Lothian who would have more impact on the history of Scotland than any other native of the county. Around 1513 at Giffordgate, across the River Tyne from St Mary's church in Haddington, John Knox was born. Educated in the town, he went on to university, probably St Andrews, and then was ordained as a Catholic priest. He also received some training in the law. Drawn to the ideas of the religious reformers, Knox attached himself to the Lutheran, George Wishart, and they came to Haddington to preach.

As the Reformation gathered momentum in Scotland and the old church was swept away, the social landscape altered profoundly. The nunneries at North Berwick and Haddington were wound up and their possessions granted to laymen. The earl's ferry to Fife was still making crossings in 1585 but it had finally fallen out of use in the 17th century as the prohibition on pilgrimages tightened. John Knox was central to the pattern of early reforms, and anxious not to leave a vacuum in society, he strongly advised the new church to set up a parish structure which could provide education, ministry and poor relief. And it worked well. Knox's vision of a school in every parish and a college in every toun created a literate and well-educated Scotland and fostered a tradition of regard for learning which has only recently faltered. It is appropriate that Haddington remembers her most illustrious son by naming her school Knox Academy.

A compelling motive for the widespread availability of schools was religious. Believers in the Protestant version of the faith did not wish to depend on a priest to interpret the Bible for them – with all his mumbo-jumbo. To gain salvation they needed to read the word of God for themselves. In this way what was called a godly commonwealth was established, but not all of its aspects were attractive. Towards the end of the 16th century an obsession with witchcraft and the danger that witches might pollute the godly commonwealth began to disfigure much of Scotland, and especially East Lothian.

James VI took a detailed and perverted interest in this, publishing a treatise of his own in 1597 called Daemonologie. It was partly prompted by the case of the North Berwick witches.

In 1589 King James was escorting his new bride, Anne of Denmark, on a sea voyage to Scotland. A furious storm blew down the Firth of Forth and the royal couple were fortunate to make landfall with their ships intact. A coven of witches was blamed and the

confession of Geilie Duncan, a serving lass from Tranent, triggered the sequence of appalling events which then unfolded. Tortured beyond endurance she described how a coven had met at St Andrews Parish Kirk in North Berwick to perform strange ceremonies designed to drown the king and queen. Others were named and hideously tortured and questioned, occasionally with James VI in attendance. Ultimately several were burned alive at the stake in front of jeering crowds.

East Lothian kirk sessions continued this hysterical pursuit well into the 17th century. One of the most notorious tormentors of alleged witches was James Kincaid of Tranent, and after he had finished with them, hundreds of poor souls deranged by pain would confess to anything, however bizarre. Most were burned, some hanged. Even allowing for a potentially misguided application of modern sensibilities over the span of more than three centuries, it was a disgraceful, shameful episode.

The international politics of fundamentalist religion were often played out over the landscape of East Lothian. In order to secure the Protestant faith many signed the National Covenant in 1638 at Greyfriars Kirkyard in Edinburgh. It was nothing less than a covenant between God and Scotland, His chosen nation, and it was the cause of seemingly endless conflict throughout the rest of the century.

While Oliver Cromwell and his soldiers controlled the republican commonwealth in England, the Scots proclaimed Charles II king – provided he signed the National Covenant, which of course he did. Cromwell was incensed at the Stuarts being given a base in Scotland. The New Model Army mustered and marched into Scotland with a fleet sailing up the east coast in support. A Scots army under David Leslie stood in the way, and in fact forced the English to retreat as far as Dunbar. For once advantage lay with the defenders – but this was soon dissipated by the zeal of covenanting ministers. Ignoring Leslie they purged the army of ungodly elements, mainly the battle-hardened professional soldiers who made the Scots army really formidable, and proceeded to lead a force of undisciplined ministers, kirk elders and laddies down from Doune Hill to attack Cromwell's astonished roundheads. The soldiers of the Covenant were quickly cut to pieces and 10,000 taken prisoner. By the end of 1650 Cromwell had installed himself in Edinburgh Castle and was master of Scotland.

Within two generations cross-border conflicts like the Battle of Dunbar would be consigned to history. In 1707 the union of the Scottish and English parliaments was shoved, brokered and fiddled through despite a chorus of popular objection in both Edinburgh and

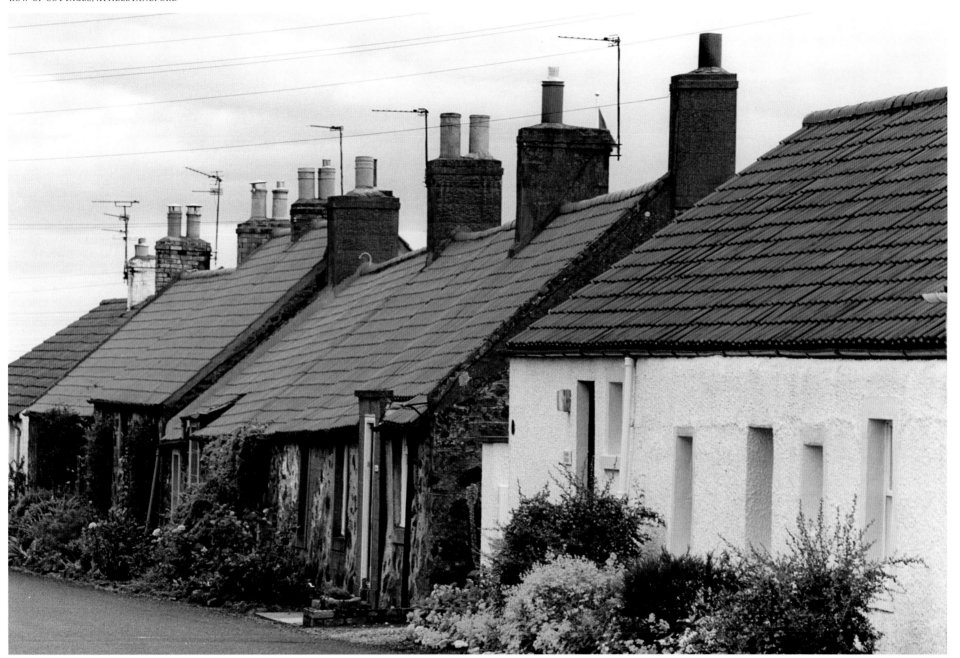

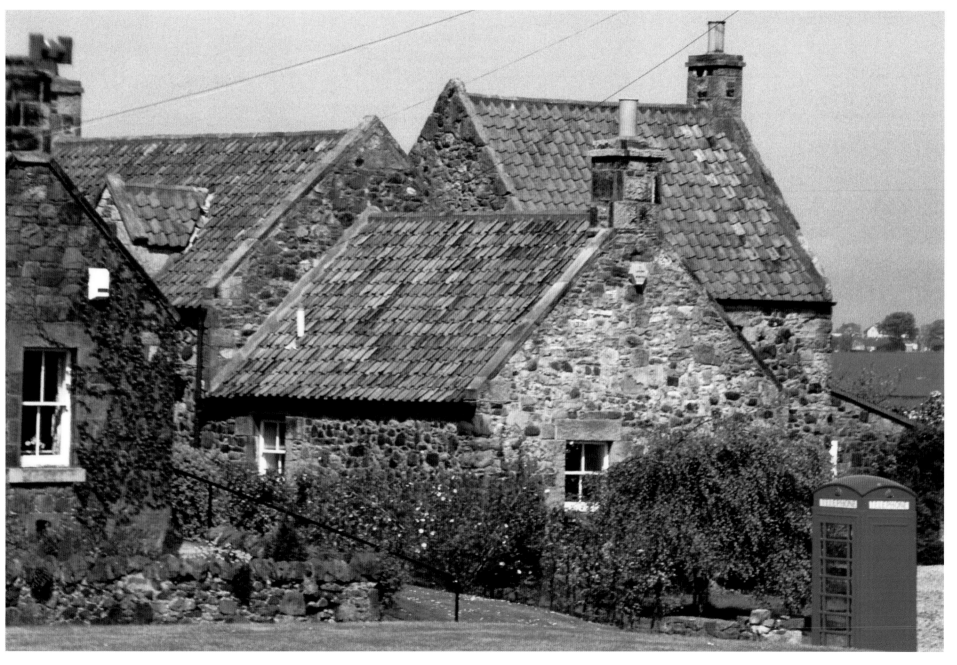

London. But it was good news for East Lothian. No more would two nations settle their differences in its grainfields and farm places. There would be one more great battle in the county, but international conflict began to fade into history after 1707.

As life promised to grow more peaceful, East Lothian settled to what it traditionally did best. The 18th century saw immense improvements in farming – although this judgement depended on a particular point of view. East Lothian's farms became larger but this development cost many their homes and livelihoods. Small tenancies were absorbed into bigger units, their houses often demolished and the kitchen gardens ploughed up. These Lowland Clearances have attracted much less attention than what happened in the Highlands, but many tears were shed in East Lothian and Berwickshire as families were forced to abandon their homes.

Seaweed had long been gathered by large and small tenants and rotted down for use as a fertiliser, especially by those whose fields lay near handy beaches. But lime began to be spread to improve soil quality and this was more important than ever as new root crops were planted. In the 1740s potatoes became a field crop, turnips were sown as winter feed for beasts, and kail was eaten by human beings. It had the unusual quality of liking frost, which was thought to give the kail a pleasant peppery nip.

The most wide-reaching agricultural innovation of all was the invention of the swing-plough. A Berwickshire blacksmith called James Small had the brilliant idea to design a plough which was cast as one piece in iron. He gave the share its characteristic slightly screwed shape and streamlined the frame.

Small's ingenuity had a revolutionary impact, in essence creating the look of the countryside we see now and which we mistakenly believe to be very old and traditional. The new plough could delve deeper and allow heavy, wet soils to drain more readily. By the end of the 18th century more land was brought into cultivation, fields became a more rectilinear shape and were generally bigger. And farm labourers became fewer. With the auld Scotch ploo an army of plough-followers was needed to tidy up its trail of big clods, half-turned furrows and to pull out the weeds. Small's design turned the sod over completely, left no clods and covered the weeds so that they could act as a mulch. The swing-plough needed only a pair of strong horses to pull it through the ground as one skilled man guided it.

While farmers improved their land and became more productive, politics and drama did not quite desert the East Lothian landscape. In 1715 the exiled Stuarts attempted armed insurrection against what they saw as the usurping Hanoverian dynasty. Part of the Jacobite

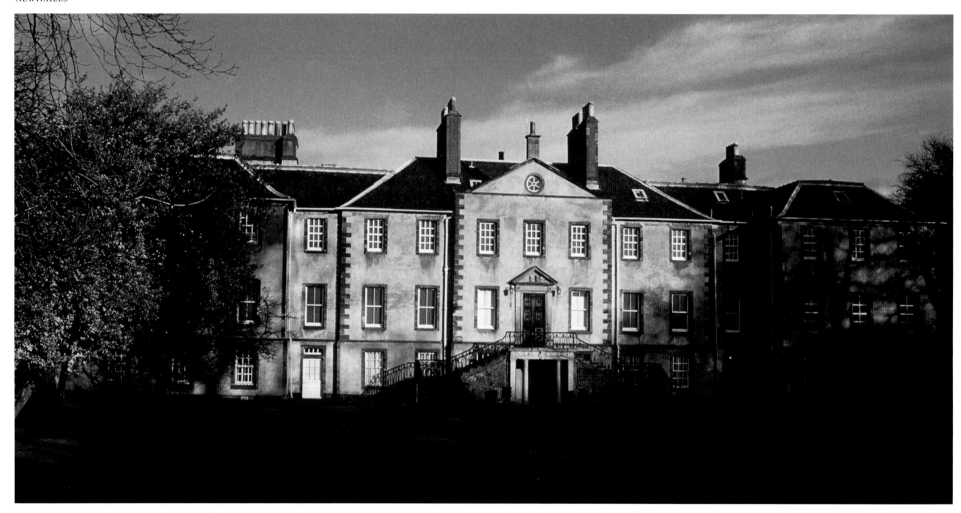

army crossed the Forth from Pittenweem to North Berwick so that they could march on Edinburgh from the east but with defeat at Preston in Lancashire and irresolution and confusion on every side, the rebellion rapidly fizzled out. It was the Stuarts' best chance to seize back the throne.

By 1745 it was too late. However, the military conduct of what the Gaels called Am Bliadhna Thear-laich, the Year of Charles, was very different. Crucially the rebellion failed to attract English Jacobite support, but Charles Edward Stuart's Highlanders almost succeeded without their help. This was in large part due to the tactics of a brilliant general, Lord George Murray.

Within only four weeks since his landing in Moidart, the prince was in Edinburgh without having had to fight a battle in the north. Outmanoeuvred, the government army had been forced to sail south from Inverness to confront him, and they disembarked at

Dunbar on 17th September. Having quickly marched along the coast road, they formed up in battle order near Prestonpans to wait for the Highlanders. Expecting an attack from the west, General Sir John Cope had chosen his ground well with protection on one side from a stone dyke and an impassable bog on the other. In front lay a ditch which would blunt the feared Highland charge.

But nothing went to plan. From an East Lothian Jacobite, Robert Anderson, Lord George Murray learned that there was a secret path through the impene-trable bog. At dead of night, in complete silence, he led his Highland regiments through and had them form up on the eastern side of the government forces where the ground was much better. When dawn broke and General Cope peered through the grey light, he was horrified to see an entire army behind him. He swung his troops around just as Clan Cameron broke into the

charge, racing towards the redcoats. And when the rest of the Highlanders saw that the Camerons were away, they roared their war-cries, raised their broadswords and tore into Cope's terrified troops.

Incredibly the Battle of Prestonpans lasted only 15 minutes. As the clansmen swung their Lochaber axes and claymores, the redcoats broke and ran for their lives. But many were killed, perhaps as many as 500, in the ferocity of the first onslaught. Prince Charles galloped about the battlefield imploring his soldiers to stop the slaughter, shouting that the government men were also his father's subjects. It was no use. The Highlanders understood only Gaelic and thought their commander-in-chief was shouting encouragement.

Prestonpans was the last battle to be fought in East Lothian; but it was not the last time the county was threatened by war. The American pirate, John Paul Jones (who was born near Dumfries), sailed up and down the

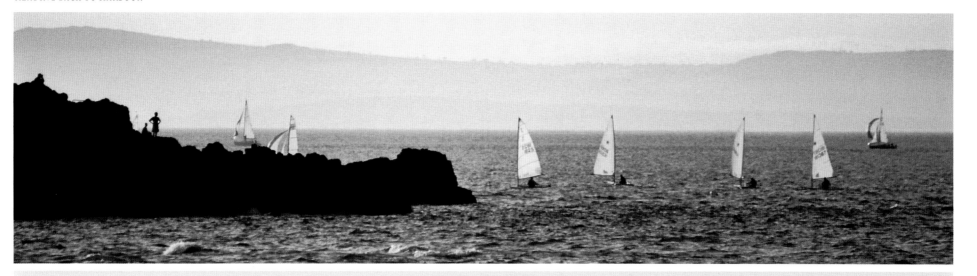

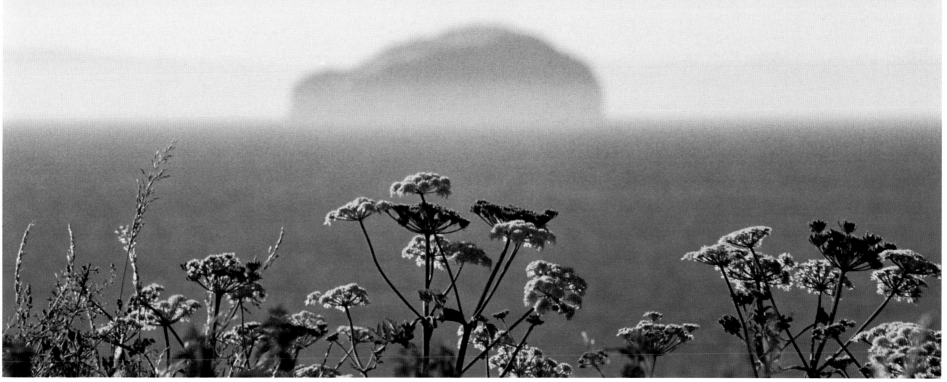

BASS ROCK

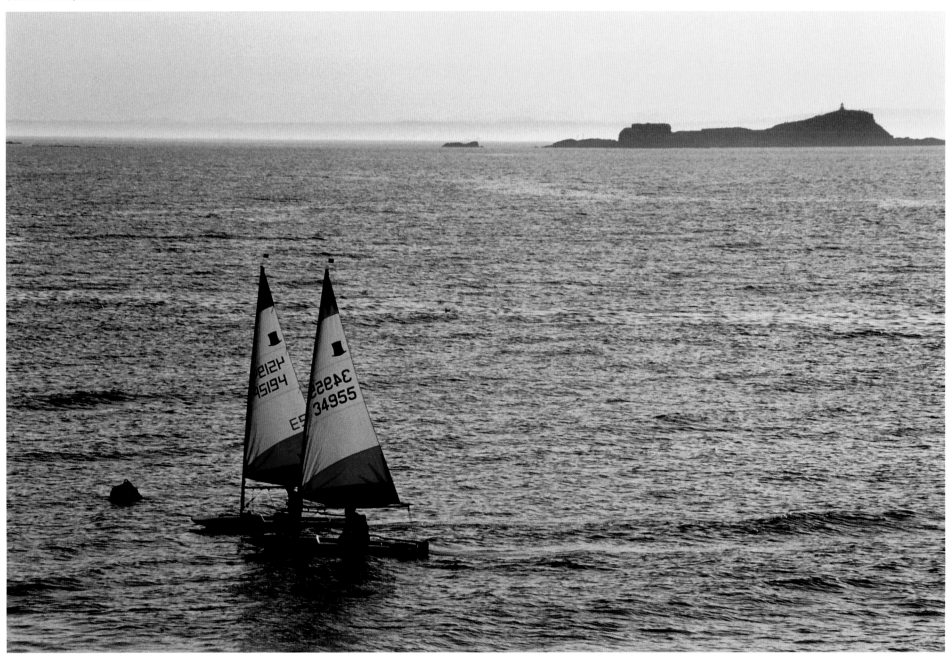

North Sea coasts of Britain, harrying and attacking shipping of all sorts and raiding ports when he could see an opportunity. His small squadron entered the Forth, had a look at Dunbar's defences and decided that there were easier options elsewhere.

In 1789 the French revolution set fire to the map of Europe. By 1794 the Terror and the seemingly endless executions had subsided and France began to engage with her external enemies. Britain's ruling class were of course anxious to suppress any wildfire spread of revolutionary ideas and to defend these shores from invasion. When compulsory military service was introduced, both to swell the ranks of the forces but also deplete the number of potential members of a revolutionary mob, there was vociferous objection, especially in East Lothian. In 1797 a large band of objectors gathered in Tranent. Tempers were raised and the dragoons reacted with more than excessive force. Shots were fired and several people killed in the streets. The mood was not helped by the fact that two English companies of soldiers were involved; the Cinque Ports Cavalry and the Pembrokeshire Cavalry. Much racist abuse was exchanged. In all, twelve people were shot dead as the troopers ran amok, chasing men and boys down country lanes and through cornfields. For fear that other towns and their people would take to the streets and the problem escalate, news of what became known as the Tranent Militia Riot was suppressed and no officer or trooper was ever reprimanded, far less court-martialled.

When Napoleon Bonaparte became First Consul and then Emperor, the British government galvanised the countryside, particularly coastal areas, to make preparations to resist a French invasion. With its flat and fertile hinterland, and an arterial road, to say nothing of several good harbours and gently sloping sandy beaches, East Lothian was thought to be a prime strategic target. A beacon was set up on North Berwick Law to be fired if landings began, and the ruin of the signallers' bothy can still be seen near the summit. A fired beacon on the Law could have been clearly picked up at military HQ at Edinburgh Castle.

Dunbar became a garrison town. In response to John Paul Jones' near-visit, a naval battery was built on Lammer Island at the harbour mouth. Soldiers camped nearby and eventually Lauderdale House was transformed into a cavalry barracks, the headquarters of the East Lothian Yeomanry Cavalry and later the Lothians and Border Horse. The town was home to permanently posted detachments of soldiers until the end of the Second World War.

Napoleon's fleet never appeared off East Lothian and after his final defeat at Waterloo, there was a degree of relief – and disappointment. War had kept prices high for farmers and many had done well. But barley

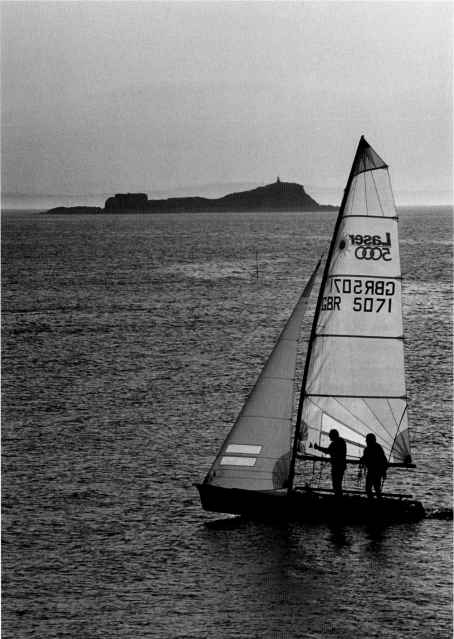

134

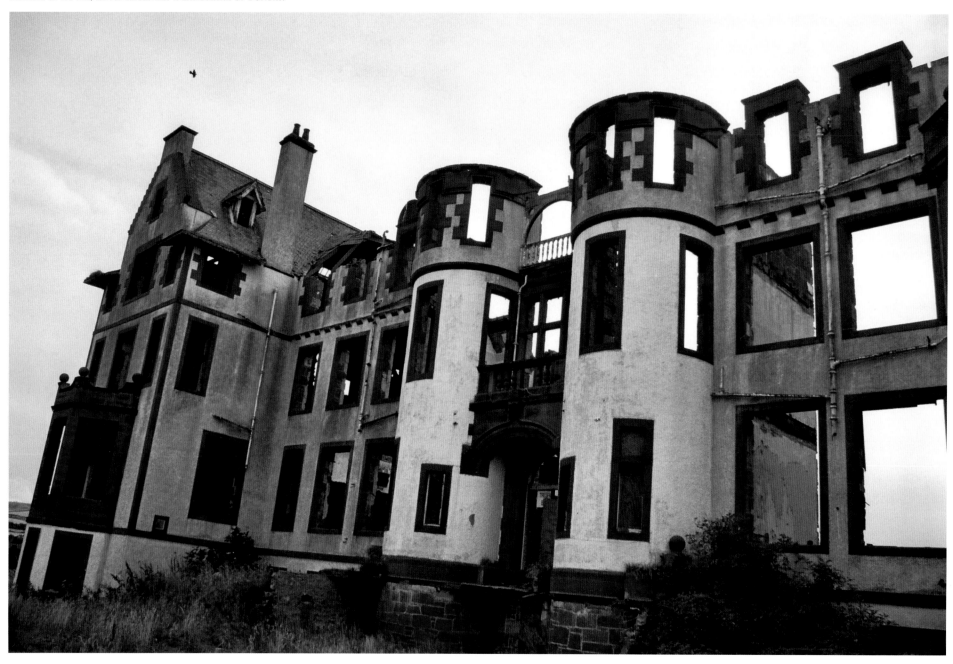

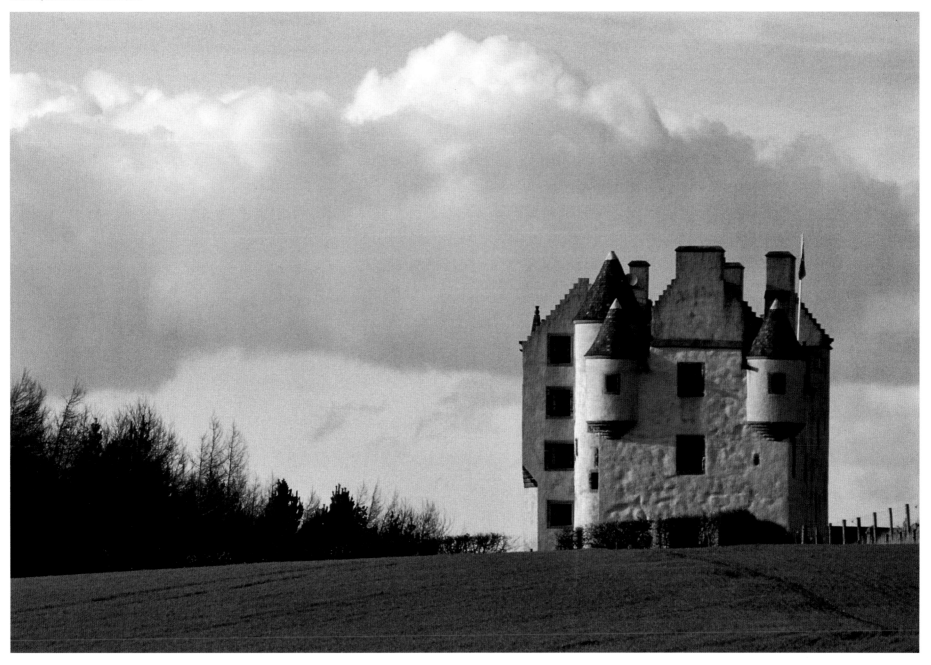

had other uses. Known as a drink crop it was of course the main ingredient in distilling. In the 19th century East Lothian had no less than nine distilleries, the largest, at East Linton, turning out 500,000 gallons of whisky a year. Only Glenkinchie at Pencaitland remains now. Beer was originally a local by-product of whisky. Dudgeon's Belhaven Brewery was at first only a maltings, such ale as was made being sold to local people. Happily it is still going strong even though ownership has passed out of the area. But it was a sad day in 1969 when John Fowler and Co. of Prestonpans closed its doors. For many years the company had brewed bottles of Fowler's Wee Heavy, a great surprise to many young men who thought it was only beer.

In the second half of the 19th century more than fifty per cent of East Lothian's people lived and worked on the land but because of the consolidation and gradual mechanisation of farming, the pattern of agricultural employment had evolved into what was known as the term system. Workers had a contract, almost always verbal, for a term, a part or whole of the agricultural year. When the term expired, the farmer either spoke to a farm hand and negotiated pay, payment in kind (known as gains this was a much-valued annual supply of potatoes, coal, oatmeal and other items) and a tied cottage or house. Those not spoken to were effectively sacked and they had to go to one of the hiring fairs held in Haddington or another town. There workers stood in groups while farmers circled around them on a tour of inspection. It was a demeaning spectacle.

When a bargain had been struck, some farmers expected a ploughman to supply a bondager. This was a female worker bonded to him by an agreement that she could live in the tied cottage, was fed by the ploughman's wife (if he had one – it was more awkward if he did not) and paid a pittance. On the 19th century farms of East Lothian and southern Scotland men mostly worked with horses at ploughing and carting while women did all the back-breaking labour of digging, singling, weeding, muck-spreading and milking. It was a very hard and unrelenting life which, thankfully, came to an end with the advance of even greater mechanisation in the 20th century. When the Women's Land Army sent young recruits to work on farms in the Second World War, many – very ironically – found the experience to be a liberation. They learned to drive and do a 'man's job'. Many returned to East Lothian to live after the war ended, unable to stay away from the countryside they had come to love.

Coal mining in the west of the county developed, but it was never a very significant sector of the Scottish coalfield. In 1900 there were only 1,500 miners working in East Lothian producing one per cent of Scotland's

output. Fishing probably employed more people and by 1881 the herring trade was booming with more than 30 boats working out of North Berwick alone. East Lothian's harbours were busy with all sorts of trade, ships a far quicker and more reliable form of transport than anything on land.

East Lothian tourism had a unique selling point. Competitive golf was probably not invented in St Andrews or Edinburgh but in Musselburgh. The nine hole course was the home of the oldest golf club in the world and offered the oldest trophy, the Old Club Cup. Other courses were laid out along the links of the East Lothian coast; North Berwick (1832), Gullane (1854), Dunbar (1853) and Luffness (1870s) and many more.

The early Open Championships were played over 36 holes and rotated between three different courses which in those days each had a different number of holes, there being no standard layout. This meant that only two rounds had to be played at St Andrews (which happened to have 18 holes), three at Prestwick (12) and four at Musselburgh (9). Five Musselburgh players have won the Open 11 times between them and perhaps that is because they had to play their home course most often. It may also have helped that the regulation size of a golf hole on the green was (and still is) based on the size of the cutter at Musselburgh. The Open is now only played in East Lothian at Muirfield, near Gullane, but perhaps Musselburgh should come back on the rota to encourage more home victories.

Golf brought visitors in large numbers, and some would say a high class of visitor too. A. J. Balfour was prime minister between 1902 and 1905, but more important he was a member of North Berwick Golf Club in the 1890s. Whittingehame Estate belonged to the Balfour family and the future prime minister was born there, eventually inheriting the property. A. J.

Balfour also had a house near the town – which became a focus for other wealthy incomers. The Tennants, the Chambers, the De Zoetes and others all built imposing villas near the bracing beaches and wonderful old golf links. The game was played by all social classes and it was said that the Fisherrow fishwives of Musselburgh were keen golfers – and footballers.

The Edwardian heyday of the East Lothian resorts has left its mark. Large hotels and villas abound and good, solid stone-built architecture has lent a settled, even prosperous air, inhibiting much new development. Many of the grand old houses have become nursing homes or been subdivided. A few of the hotels have been closed but golf has grown in popularity and the sheer number of excellent courses in East Lothian has traditionally sustained a long tourist season.

When Britain's small professional army was all but destroyed in halting the German advances in the First

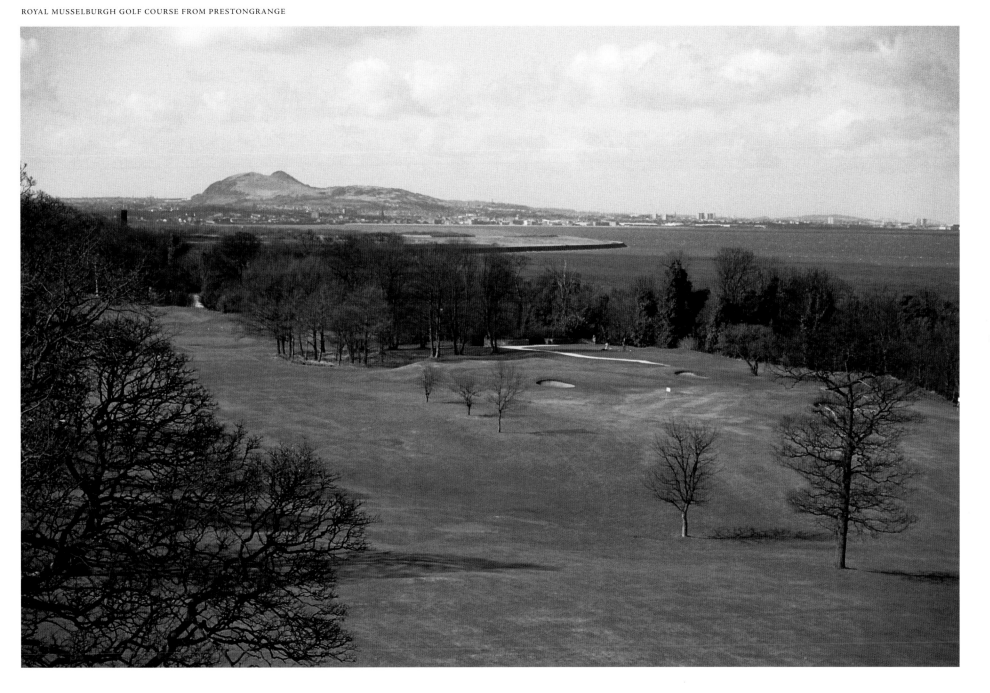

World War, a massive recruitment drive emptied East Lothian's towns, villages and farms as fatefully as elsewhere. Particularly in villages in the rural hinterland the memorials make grim reading. It seems impossible that such small places could have produced so many young men to be slaughtered in the trenches. In 1918 their families and the survivors witnessed an awesome sight, an emphatic full stop to all those numbing losses. The Imperial German Navy sailed into the Forth to surrender.

It was the end of an era. To the more perceptive it was the end of Victorian Britain; the zenith of empire, of economic and military power had passed and in the decade that was to follow the world would plunge into depression. The large estates which had patterned the East Lothian landscape began to break up, their farms often sold to sitting tenants who had been canny enough to save in wartime when food prices were sky-high.

Blowing whistles and brandishing revolvers, officers had led their men over the top in the murderous trench warfare of 1914–18 and thousands were killed in the first moments of battle. Proportionately fatalities had been devastating amongst the landowning classes. This left many large estates in the hands of ageing parents or distant relatives and it usually happened that neither group was willing to carry on and wanted to sell up. Death duties and debts also forced sales. In the 1920s and 30s more than forty per cent of Scotland's farmland changed hands and two-thirds of farms came to be occupied by their owners.

As prices dropped in the depressed 1920s, the land depopulated even more. But one enterprising East Lothian woman did something creative, something which has enriched country life ever since. In 1917 Mrs Catherine Blair of Hoprig near Macmerry founded the Scottish Womens' Rural Institute. The idea spread rapidly all over Scotland and was imitated in England and Wales. It was immediately popular because it was a rare thing, an organisation run by women for women and which got them out of the house and into the cheerful and busy company of people who understood each other. Branches opened at Longniddry and Tranent, and although somewhat less popular than it used to be, the SWRI still flourishes in East Lothian with 17 branches and 417 members. Thankfully none of them appear to have any inclination to produce calendars.

Tourism suffered after the First World War, North Berwick, Gullane and Dunbar never regaining their former appeal despite strenuous efforts by their town councils. Inhibitions did abate though and mixed bathing was permitted in the large seawater pools as swimming and diving became great enthusiasms. Costumes shrank a little to become skin-tight and ladies

favoured the sunback or no-back style. As sunbathing became voguish, East Lothian took to advertising itself as the drier part of Scotland. Drier than the competition – the Clyde resorts – was what they meant.

The exodus from working on the land was less painful than in more remote areas. East Lothian's small towns supported some industry with the likes of Brunton's Wireworks in Musselburgh employing as many as 2,500. Evidently Edinburgh migrants could also find work in the county and Sean Connery spent a cheerful few months as an assistant to an undertaker in Haddington. The public sector became a prime source of jobs (East Lothian Council is now the largest employer – and by some distance) particularly in a time of deep economic depression. The police, for example, much preferred to recruit the big, strong and steady lads from country districts.

When Britain's politicians and senior soldiers

began to prepare for a second war with Germany in the late 1930s, they realised that the slaughter of 1914-18 could not be repeated. A citizen army, they judged, would simply refuse to suffer such casualties again, so even though the war was fought on a very much greater scale, the 1939-45 lists on war memorials are much shorter. Just as it had been in the Napoleonic era, East Lothian was considered a likely landing ground for invading forces. Beaches at Aberlady, Gosford, Gullane, North Berwick, Tyninghame and Dunbar and elsewhere still have concrete tank traps here and there. Large buildings such as hotels and grand villas in the towns were commandeered for military use, and even the caddies' shelter on North Berwick's West Links concealed an anti-tank gun. And tragically, trenches were dug on the fairways and greens of many golf courses. Airfields at Drem, East Fortune and Macmerry were used to launch bombing raids across the North Sea.

Once again East Lothian supplied the stage for a surrender. Three Junkers aircraft packed with German officers landed at Drem in 1945 to offer the formal surrender of occupied Norway. No doubt they preferred British custody to either Norwegian or Russian.

After the war ended the world changed again. Believing that the governing classes of Britain had badly let them down with two immensely destructive wars fought within a generation, and determined to see a new nation rise out of all that misery, the electorate (and especially the postal-voting soldiers) swept Winston Churchill from power in a Labour landslide. It was the first general election for ten years and J. J. Robertson won the old parliamentary seat of Berwickshire and Haddingtonshire for Labour and held on to it until 1951. Sir William Anstruther-Gray won it back for the Conservatives and fought off close challenges from Labour until John P. Mackintosh defeated him in 1966.

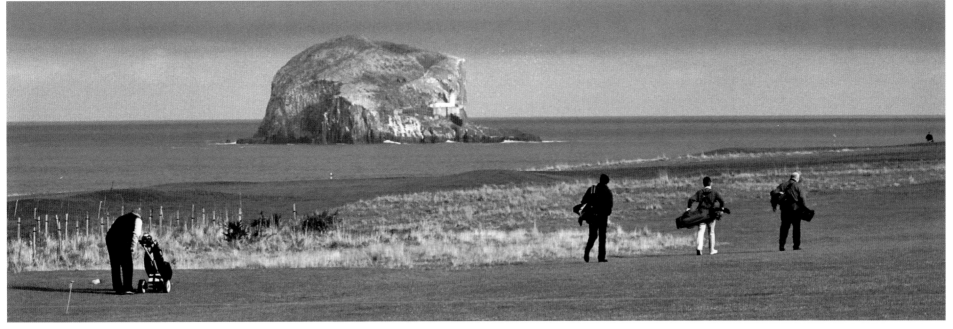

GLEN GOLF COURSE, NORTH BERWICK

HORSE RIDING ON SEACLIFF BEACH

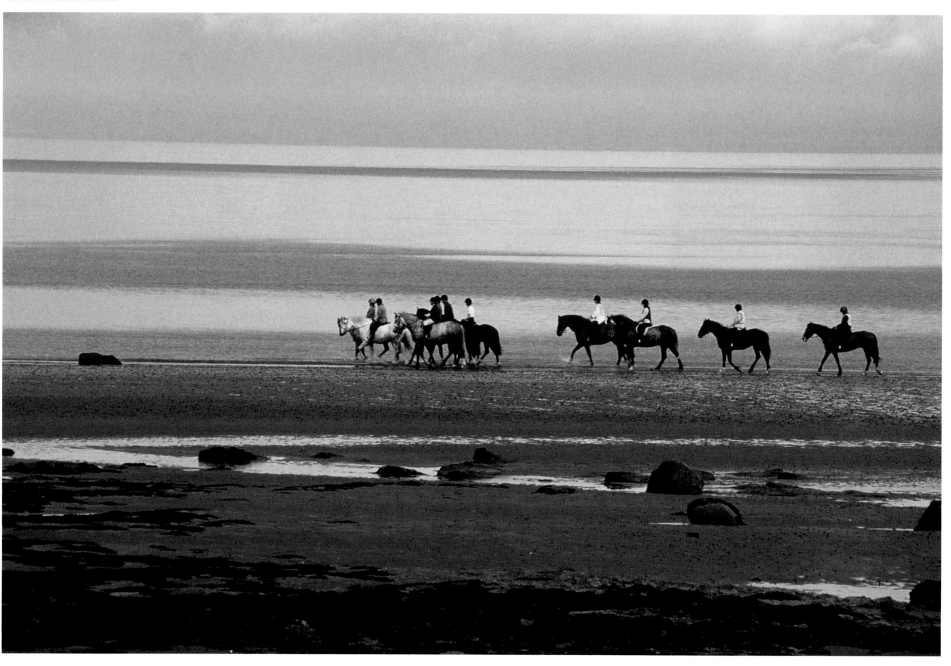

ISLE OF MAY FROM WHITEKIRK GOLF COURSE

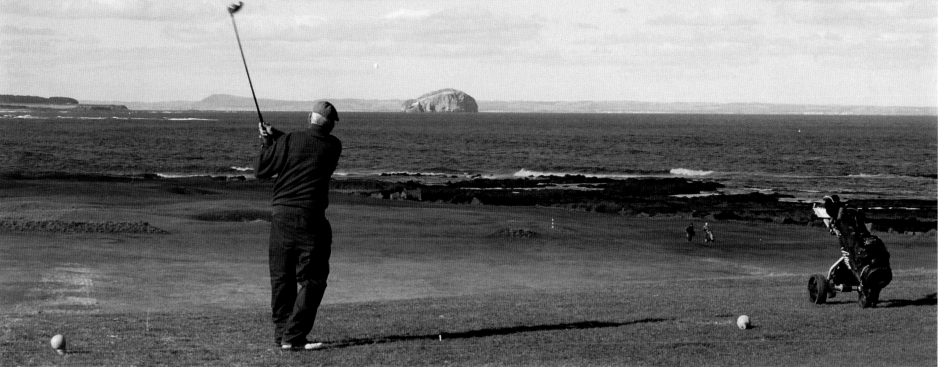

WINTERFIELD GOLF COURSE

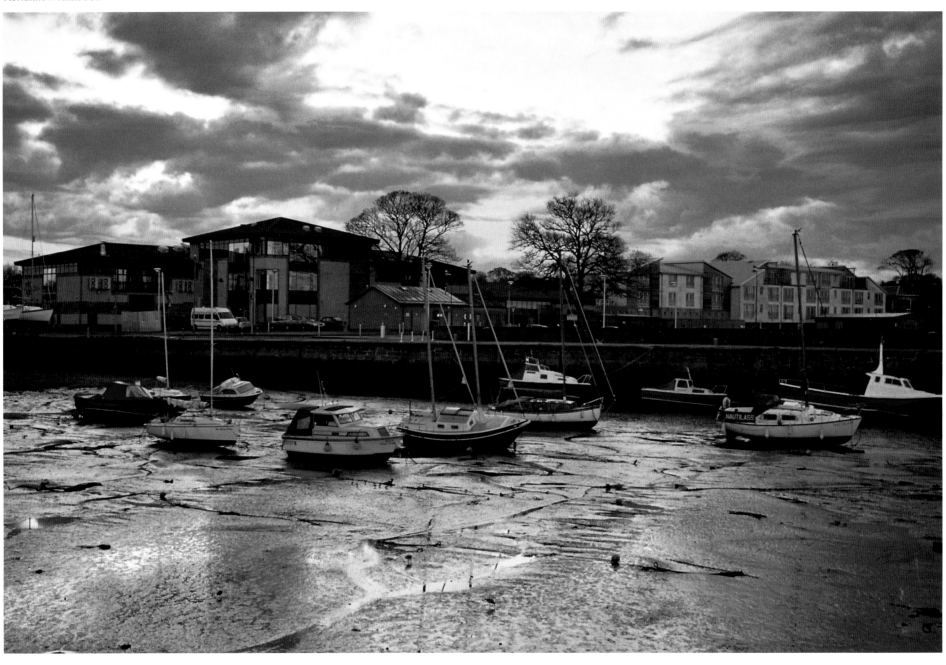

Boundary changes in 1983 (losing Berwickshire to a Borders constituency and gaining Musselburgh) made East Lothian a safer Labour seat and Conservatives have done no better than a good second ever since.

In 1946 another revolution impacted on farming. The Ferguson tractor was produced in large numbers and at an affordable price. Designed by an Ulsterman, Harry Ferguson, and manufactured by the Standard Motor Company of Coventry, its widepread use changed the face of East Lothian agriculture rapidly. Between 1946 and 1956 half a million wee grey Fergies rolled off the production line and as they arrived on farms, horses left. By 1960 it was unusual to see horse-working and many old stable blocks and cart-sheds were knocked about to accommodate a tractor and tractor-powered machinery. What made the Fergie so attractive was more than price or the fact that it would start in a storm, it was also the design of the back end. The three point linkage was adaptable to different implements and it could power them in such a way as to operate as a single unit. The tractor did much more than simply pull things.

The arrival of the Fergie persuaded more farm workers to seek employment in towns and cities, but with the advent of a Labour government and the drift of the Conservatives to a more electable centre ground, greater opportunities in the public sector and education opened up. For a brief window, between c1960 and c1980, it was possible to enjoy an excellent – and free – education in Scotland. The number of graduates schooled at Knox Academy, North Berwick High School, Preston Lodge High School, Ross High School, Musselburgh Grammar School and Dunbar High School rose steeply.

Old East Lothian industries declined in the 1950s and 60s. At Preston Links the last deep mine closed even though substantial reserves under the Forth remain untouched. The cost of extraction became more than the market could bear. Nearby a similarly ancient business ended with the closure of the last salt pans in 1959. Cockenzie Power Station was designed to be coal-fired and its fuel was to come from the open-cast pit at Blindwells, but this ceased production in 2000 and Cockenzie was run down. At the eastern end of the county, amid sustained protest, the nuclear power station at Torness opened. It is now the second largest employer in East Lothian with 620 people working there.

In the post-war decades cultural life has renewed itself with vigour and some style. The Brunton family gave generously to enable the building of the Brunton Hall at Musselburgh, and after a legendary and inspirational concert given by Yehudi Menuhin in the ruins of St Mary's Haddington, the Lamp of Lothian Trust was founded in 1967. It has been influential in

promoting the arts in general and classical music in particular.

Before 1975 the Scottish Office in Edinburgh had to deal directly with almost a thousand separate civic institutions – town councils, county councils and others. Sadly it was decided that drastic rationalisation was needed and larger units of local government were created. At midnight on 15th May in 1975 the ancient burghs of Haddington, North Berwick and Dunbar, and the more recent police burghs of Tranent, East Linton, Prestonpans and Cockenzie & Port Seton all ceased to exist as Lothian Region came into being. The new arrangements were found to be ill-fitting at first and in 1996 East Lothian Council was set up and Musselburgh absorbed into it.

With a population of 90,000 the new region is small and being so close to Edinburgh it could easily be overwhelmed by the booming economy of a new capital city. Dormitory town status may await the old burghs, and villages and farm cottages might be gentrified even more. The main railway line running east and then south to London will carry more and more who work in Edinburgh but prefer the tranquility of East Lothian and the clear personalities of its small towns to the relative anonymity of the city. The population is already expanding and is likely to continue growing. Industry and employment will change and factories, coal mines and salt-panning have faded into history. As commuters inject money into the local economy, service and retail businesses will expand to supply a more diverse market. Hotels, restaurants, speciality shops, craft-based businesses, companies driven by technology – the so-called knowledge-based economy – are likely to become common as East Lothian re-invents itself once again. And the look of the place, both the natural and built environments is unlikely to change radically as conservation and sensible planning exert their new power. In 1996 East Lothian got its identity back and it will not be submerged. Too much has happened, too much history has rumbled across the landscape for East Lothian to become anything other than itself. If this short history has shown anything, it is the length and depth of a famous story, a tale of prehistoric pioneers, of Celtic kings, saints, desperate battles, quiet revolutions on the land and the steady beat of a distinctive heart. Those who climb up the gentle slopes of the Lammermuirs and take the time to look back towards the humps of Traprain Law, the Bass Rock and North Berwick Law can see a landscape full of experience, full of memory, a horizon pierced by the spires and rooflines of towns which seem always to have been there, settled into the folds of the land, roads made by the tramp of people, grainfields flowing down to the seashore. They can see a place unlike any other.

164

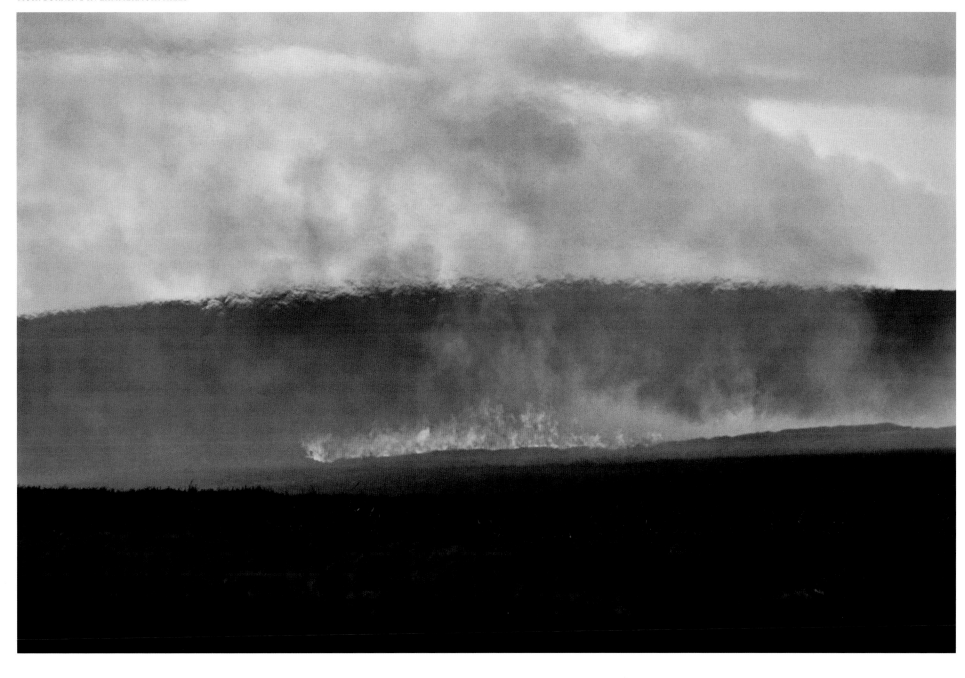

166

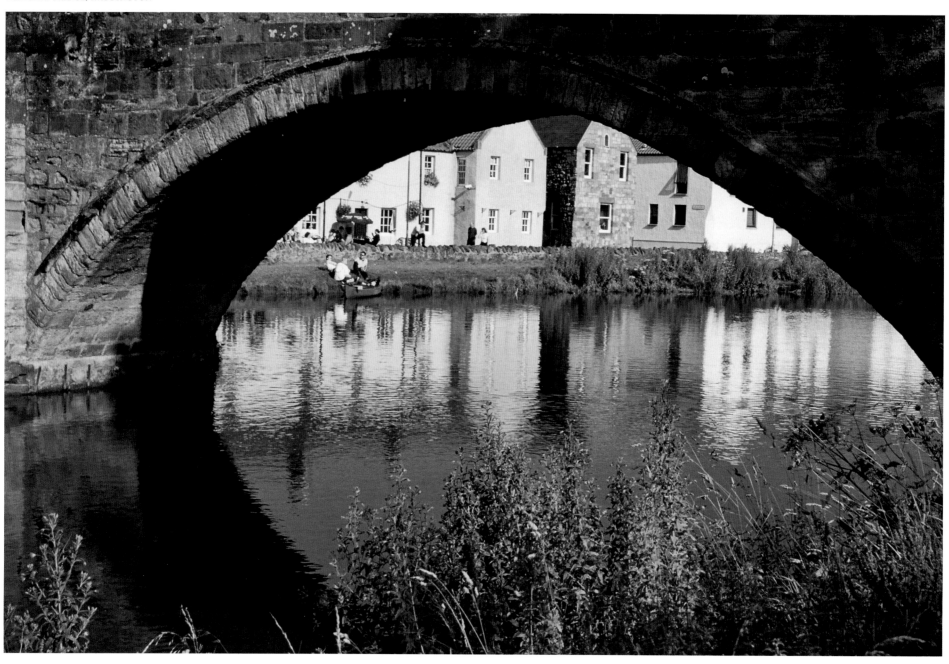

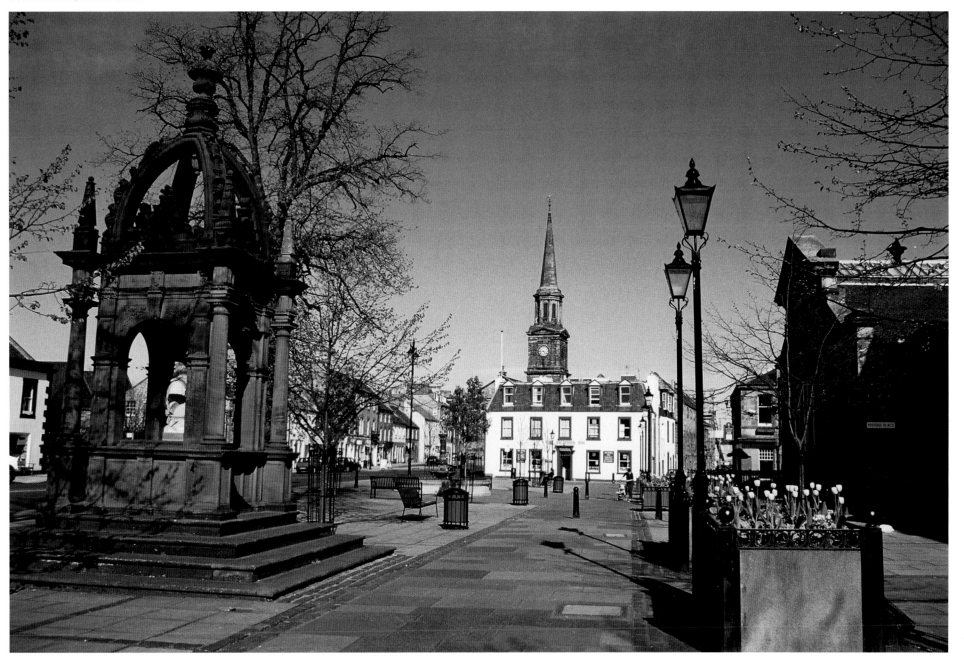

170

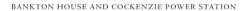

FISHING BOAT AND CORMORANTS ON ROCK

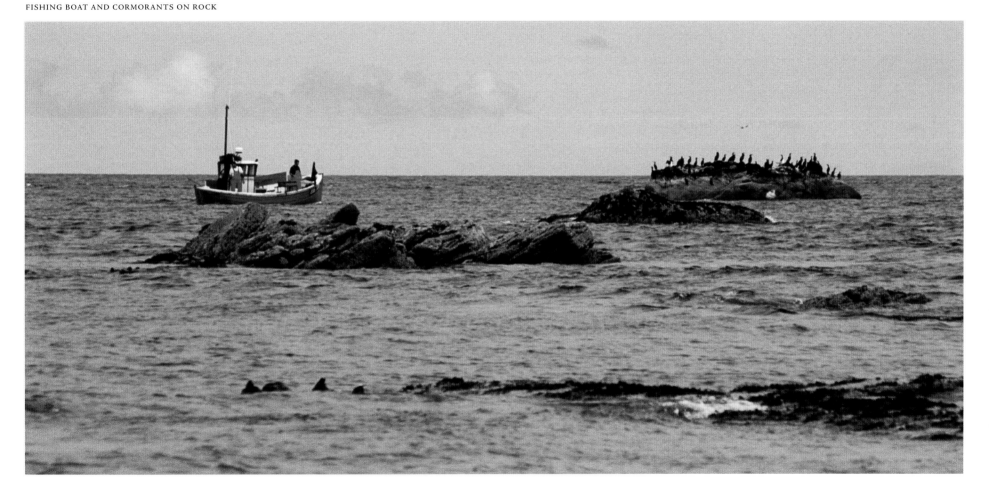

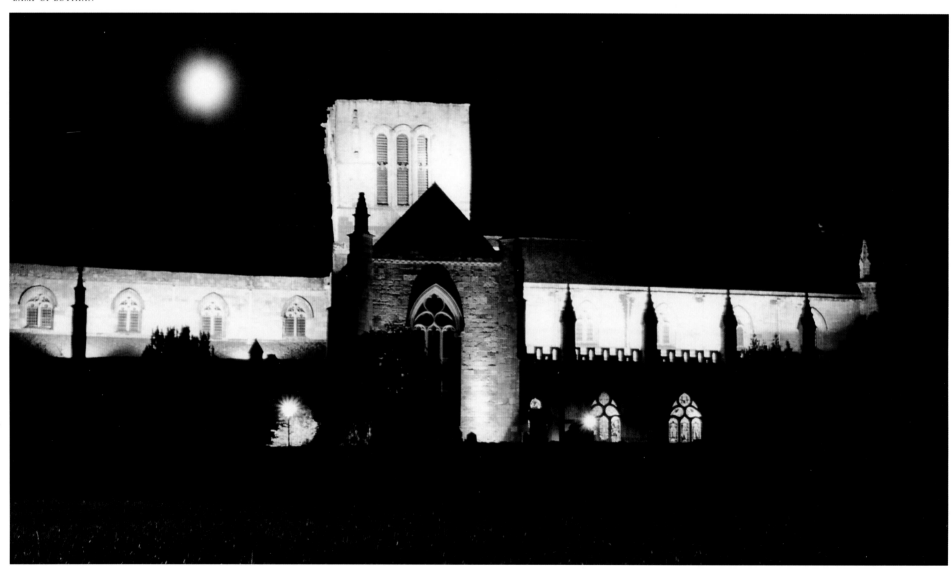

CHIMNEYSCAPE, DUNBAR

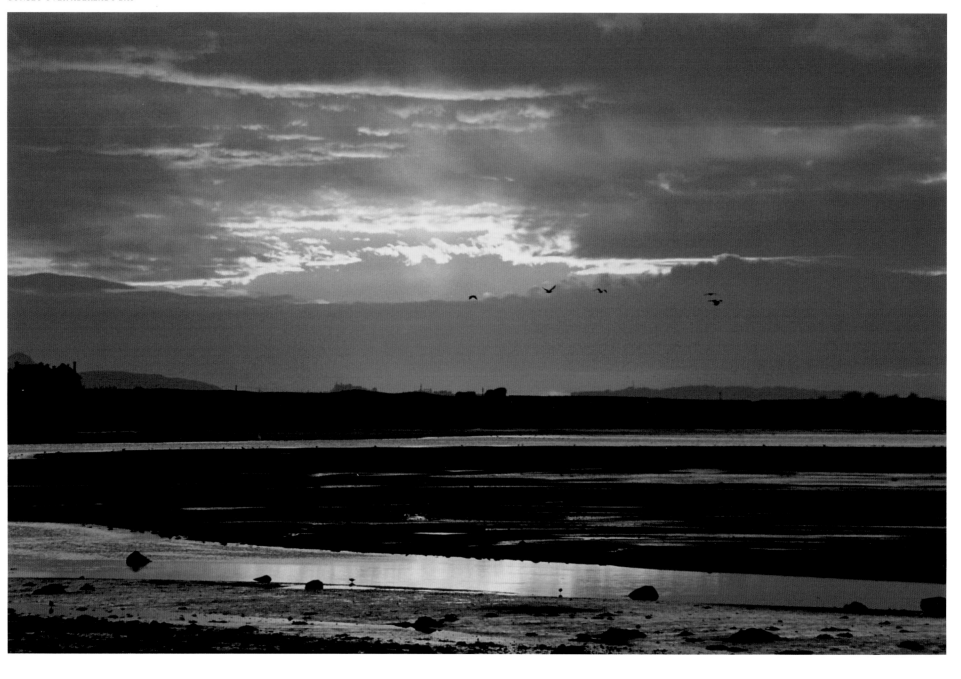

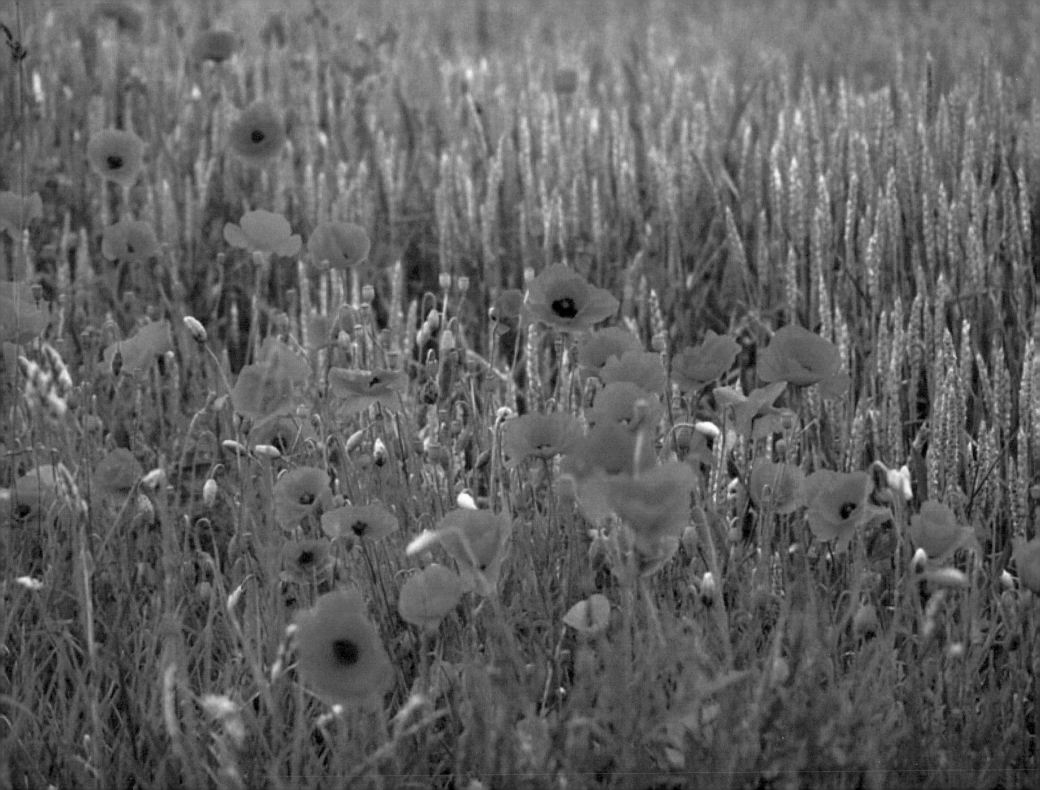